From the Courts of India

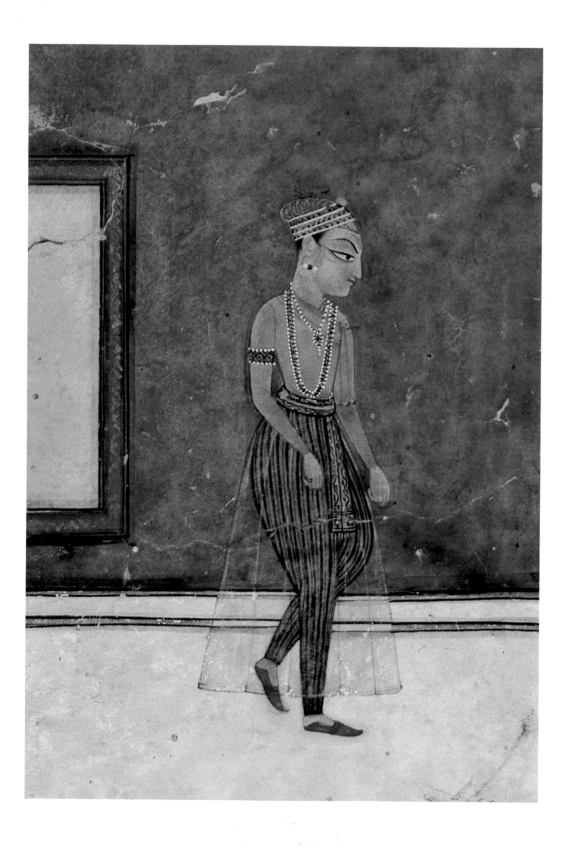

From the Courts of India

Indian Miniatures in the Collection of the Worcester Art Museum

by Ellison Banks Findly

Introduction by Glenn D. Lowry

Worcester Art Museum Worcester, Massachusetts

Library of Congress Catalogue Card Number: 80-51682
ISBN: 0-936042-30-3

Worcester Art Museum, Worcester, Massachusetts 01608

Cover: *The Storm* (p. 74)

Frontispiece: Detail of *Rādhā Welcoming Krishna* (p. 58)

For Caroline

Contents

Foreword

This publication is part of a continuing program by the Worcester Art Museum to document specific collections of exceptional importance. Although few in number, Worcester's Indian miniature paintings constitute a distinguished group not generally known to scholars and collectors and, because of their inherent fragility, infrequently exhibited.

Most of the works were purchased by Alexander H. Bullock, a prominent Worcester attorney and trustee of the museum from 1920 until his death in 1962. He was a very knowledgeable collector and a generous contributor of both works of art and funds for acquisitions. It is highly appropriate that his memory be honored by this publication.

The research and compilation of the catalogue was a labor of love for Professor Ellison Findly, who generously contributed her time and expertise in Indian art and iconography. Gaye Brown, director of publications, ably directed the manuscript through several production stages. Others who assisted in the preparation of introductory remarks and individual entries are acknowledged by the author.

Richard Stuart Teitz
Director

Acknowledgments

This catalogue is the fruit of many efforts. Heartfelt thanks go, first of all, to Glenn D. Lowry of Harvard University, whose comments on my drafts and on the miniatures themselves have been invaluable. His fine judgment of painting, his knowledge of things Islamic, and his constant resourcefulness and encouragement made it a great pleasure to work with him.

I am also immensely grateful to Vishakha Desai of the Museum of Fine Arts, Boston, for sharing her expertise in Indian manuscript painting and for her delightful translations. Thanks are due as well to Mark Zebrowski for information on our Deccani portrait; to Wheeler Thackston of Harvard University for his translations from the Persian; to Ellen Smart of the Rhode Island School of Design for her comments on our Mān Singh portrait; and to George Cuñha of the New England Document Conservation Center, North Andover, for his knowledgeable advice about paper and its preservation.

The museum staff has also been extremely helpful. Many thanks go to Librarian Hollee Haswell, who has been more than generous with her time and resources, for retrieving so much information, often times with little to go on; to Gaye Brown, for her fine eye and equally fine editing; and to the curatorial staff, especially Joanne Carroll and Sandy Petrie, for generously offering their facilities for study.

Finally, this catalogue could not have been published without the generous support of the National Endowment for the Arts, for which we are especially grateful.

E.B.F.

List of Abbreviations

Archer 1952

Archer, W. G. *Indian Painting in the Punjab Hills*. London: His Majesty's Stationery Office, 1952.

Archer 1973

Archer, W. G. *Indian Paintings from the Punjab Hills: A Survey and History of Pahari Miniature Painting*. 2 vols. London: Sotheby Parke Bernet, 1973.

Archer and Singh

Archer, W. G., and Singh, M. *Indian Miniatures*. Greenwich, Conn.: New York Graphic Society, 1960.

Barrett and Gray

Barrett, D., and Gray, B. *Painting of India*. Skira, 1963.

Beach

Beach, M. C. *The Grand Mogul: Imperial Painting in India 1600-1660*. Williamstown, Mass.: Sterling and Francine Clark Art Institute, 1978.

Binney: Mughal

Binney, E., 3rd. *The Mughal and Deccani Schools. Indian Miniature Painting from the Collection of Edwin Binney, 3rd*. Vol. 1. Portland, Oreg.: Portland Art Museum, 1973.

Binney: Rajput

Archer, W. G., and Binney, E., 3rd. *Rajput Miniatures from the Collection of Edwin Binney, 3rd*. Portland, Oreg.: Portland Art Museum, 1968.

Chandra

Chandra, P. *Indian Miniature Painting: The Collection of Earnest C. and Jane Werner Watson*. Madison, Wis.: Elvehjem Art Center, 1971.

Coomaraswamy 1916

Coomaraswamy, A. K. *Rajput Painting*. 2 vols. London: Oxford University Press, 1916.

Coomaraswamy 1926

Coomaraswamy, A. K. *Catalogue of the Indian Collections in the Museum of Fine Arts, Boston*. Pt. 5: *Rājput Painting*. Cambridge: Harvard University Press, 1926.

Ebeling

Ebeling, K. *Ragamala Painting*. Basel: Ravi Kumar, 1973.

Heeramaneck

Heeramaneck, N. M. *Loan Exhibition of Early Indian Sculptures, Paintings and Bronzes*. New York: Heeramaneck Galleries, 1935.

Objects

"Objects in the Collection from Greater India." Exhibition checklist. Worcester Art Museum, 1953.

Pal 1967

Pal, P. *Rāgamālā Paintings in the Museum of Fine Arts, Boston*. Boston: Museum of Fine Arts, 1967.

Pal 1978

Pal, P. *The Classical Tradition in Rajput Painting from the Paul F. Walter Collection*. New York: The Pierpont Morgan Library; The Gallery Association of New York State, 1978.

WAM 1953

WAM News Bulletin and Calendar 19, no. 3 (December 1953): 11–12.

Welch 1978

Welch, S. C. *Imperial Mughal Painting*. New York: George Braziller, 1978.

Welch and Beach

Welch, S. C., and Beach, M. C. *Gods, Thrones, and Peacocks*. New York: Asia Society, 1965.

Exhibitions

Chicago 1926	*Indo-Persian Miniature Paintings.* Art Institute of Chicago, Chicago, 26 April 1926.
Smith 1980	*The Bodhisattva and the Goddess.* Smith College Museum of Art, Northampton, Mass., 10 April–26 May 1980.
WAM 1926	*Persian and Indian Miniatures Lent by Various Collectors.* Worcester Art Museum, Worcester, 14 March–4 April 1926.

From the Courts of India

Almost all of the Indian miniatures gathered here were painted from the sixteenth through nineteenth centuries, and most come from either the Mughal or Rajput courts of northwestern India. Their subjects range from historical events, such as the *Birth of Ghazan Khān* (p. 22), to illustrations of Hindu poems. With their vibrant colors, astute characterizations, and simple, often bold compositions, these miniatures reflect the different tastes and beliefs of their patrons. In their varying treatment of forms and themes, they also describe the social and cultural backgrounds from which they came.

The Mughals, a Muslim dynasty founded in 1526 by Zahir-ud-dīn Muhammad Bābur, were initially foreigners to India. Their political, economic, and cultural roots lay in the Persianate culture of Transoxiana. For Bābur and his early followers, India was a country of few charms:

"Its people have no good looks; of social intercourse, and paying and receiving visits there is none; of genius and capacity none; of manners none; in handicraft and work there is no form or symmetry, method or quality; there are no good horses, no good dogs, no grapes, muskmelons or first rate fruits.... "[1]

Over the next fifty years, as the Mughals consolidated their power in the north, around the cities of Delhi and Agra, and began expanding south and eastwards into the regions of the Deccan and Bihar, these feelings gradually changed. By the early seventeenth century, Bābur's great-grandson Jahāngīr (r. 1605–27) wrote:

"From the excellencies of its sweet scented flowers one may prefer the fragrances of India to those of the whole world. It has many such that nothing in the world can be compared to them."[2]

This extraordinary change in attitude was due, to a large extent, to the political and cultural policies of Jalāl-ud-dīn Akbar (r. 1556–1605), Bābur's grandson and the first Mughal emperor born in India. Through a series of brilliant political and military maneuvers, Akbar brought almost all of the independent kingdoms of Rajasthan—controlled by Hindu rulers known as Rajputs—under his rule. In order to maintain these gains and create a stable empire, supported by his army as well as the conquered Rajput princes, Akbar developed a policy of religious tolerance. He married Hindu princesses, repealed discriminatory laws forcing non-Muslims to pay a head tax, and offered royal patronage to Hindu artists, musicians, poets, and civil servants. In doing so, he transformed the Mughals from an external threat into a dominant internal force.

The impact of Akbar's policies on the arts was tremendous. The Mughals introduced new themes and tastes to the traditional folk paintings of the villages and minor local courts. *Kālaka Complains to King Gardabhilla* (p. 16)—although not, strictly speaking, a folk painting—shares many qualities with Indian folk art, such as its large, flat areas of color and simple, hierarchical composition. Its strength lies in the immediacy of its bright colors and the naïveté of its sketchily rendered figures. In contrast, Mughal miniatures are far more complex and sophisticated. The composition of *Birth of Ghazan Khān*, for instance, is more elaborate, its colors more subtle and varied, and the characterization of its figures more intense. These differences in form are paralleled by differences in conception. The Indian painting, focused on one or two figures and simple in design, is clearly meant to serve as an illustration to the text of the *Kālakācāryakathā*. Although *Birth of Ghazan Khān* also illustrates a text, by enlarging the size of the image in relationship to the area of the writing and depicting

a large number of figures and activities, the artist has created a painting that can be understood and appreciated independent of textual reference.

A further distinction between the two paintings is that the historical event depicted in the Mughal miniature creates a sense of time and place, unlike the mythical subject of the Indian miniature. Whereas the Mughal artist describes in detail the shape, form, and texture of buildings and figures that make up his composition, the Indian artist gives only the barest suggestion of form and detail; for him these are not important elements.

The Mughal concern for detail and setting led, during the late sixteenth and early seventeenth centuries, to the development of a number of conventions enabling artists to more accurately describe their surroundings. The use of shading and modeling, as well as techniques of perspective, were borrowed from European prints brought to the Mughal court by missionaries and adventurers. This movement towards naturalism was prompted by the interest Mughal emperors took in their environment. The memoirs of Bābur and Jahāngīr abound with keen observations of strange animals, plants, and events. Under Jahāngīr these tendencies reached their climax. The emperor demanded that his artists provide illustrations for his written descriptions. His tastes ran from the mundane to the unusual, and he commissioned portraits of everything from exotic birds to dying courtiers. He wrote, for example, of Inayat Khān that

"he was one of my intimate attendants. As he was addicted to opium, and when he had the chance, to drinking as well, by degrees he became maddened with wine. As he was weakly built, he took more than he could digest, and was attacked with the disease of diarrhoea, and in this weak state he two or three times fainted.... Some days before this [his death] he petitioned that he might go to Agra. I ordered him to come into my presence and obtain leave. They put him into a palanquin and brought him. He appeared so low and weak I was astonished.... As it was a very extraordinary case I directed painters to take his portrait."[3]

This interest in probing characterizations can be seen in the portraits of Mān Singh (p. 26), one of Akbar's courtiers, and Aurangzēb (p. 30), Jahāngīr's grandson. In the former, Mān Singh's large shoulders, corpulent body, and strong, finely drawn face indicate his strength and stature; while the portrait of Aurangzēb (r. 1658–1707) shows a thin, almost emaciated man with hunched shoulders and a withered face. The emperor's forlorn expression, heightened by the austerity of his clothes, suggests a wistful longing for the days before his reckless military campaigns brought the country to the verge of bankruptcy.

Despite their enormous costs, Aurangzēb's campaigns, in the end, were successful in subjugating the independent kingdoms of the Deccan in south-central India. Since the fourteenth century, this area had been ruled by a series of extremely wealthy Muslim dynasties, centered around the cities of Bijapur, Golconda, and Ahmednagar. From the middle of the sixteenth century on, the sultans of these courts patronized the arts on a scale almost as grand as that of the Mughals. The portrait of 'Alī 'Ādil Shāh II (r. 1656–72) from Golconda (p. 32) is a superb example of Deccani painting. The sultan, standing upon a small dais, is isolated against a gold background. His beautifully patterned green robe serves as a foil for the extraordinary red plant before him. Design and line, in particular, are everything in this miniature. Whereas Mughal portraits focus on a single figure against a stark background, this painting sets its subject within a richly textured composition. Although the artist has clearly recorded

the features of the sultan, it is the rhythms of the plants and ʾAlī ʾĀdil Shāh's costume that are most striking.

The intensity of observation and exploration demanded by the Mughals of their artists was very different from the concerns of the Rajput princes, whose tastes embraced folk art.[4] From the late sixteenth century on, the latter began patronizing artists at their various courts scattered throughout Rajasthan and the Punjab. The subjects preferred by the Rajputs were the great Hindu epics—the *Mahābhārata*, the *Bhāgavata Purāna*, and the *Rāmāyana*—as well as *Rāgamālās*, or illustrations to musical modes. The central themes developed by Rajput artists tended to focus on the lives of Krishna and Shiva, reflecting the many popular cults that surrounded these gods. Krishna, in particular, received special attention, for a number of devotional movements stressed that through constant meditation and worship of him, one could directly encounter God. This searching of the soul for the divine became a major artistic theme. It was visualized either through the image of the universal lover or the various stages of human passion, from quest to consummation.

Many of these ideas reached their most eloquent expression in illustrations for *Rāgamālā* albums, which were composed by grouping individual paintings into "families." Each family contains a *rāga* ("male"), five or six *rāginīs* ("wives"), and their children, *rāgaputras* ("sons") and *rāgaputrīs* ("daughters"). During the sixteenth and seventeenth centuries, specific iconography was developed—such as the *nāyikā* ("heroine") yearning for her lover, or Krishna dancing with the *gopīs* ("cowherdesses")—which was repeated from series to series.

Meghamallāra Rāga (p. 52) is an excellent example of *Rāgamālā* painting. Set at the time of the rainy season, it depicts a king (Krishna) and his escort dancing to tunes played by their attendants. The deep blue of the king's skin contrasts with the dark red of the background and the whiteness of his lover's flesh, charging the scene with excitement that is mirrored in foreboding clouds (*megha*) above. The vibrant rhythms of the drummer's striped skirt and the agitated lines of the clouds also create a feeling of tension that suggests the passion and anticipation of the lovers.

Despite the powerful feelings developed by the painting's brilliant colors and interplay of forms, the lovers remain serene and aloof, as is typical in Rajput painting. They are not meant to represent individuals, but idealized types. Likewise, the remarkable forest in *Krishna Disguised as a Musician* (p. 60) is lush with trees and plants, but the artist has not isolated specific flora. Instead, he has reproduced a number of types, such as the leafy fronds in the center, creating an image not of a specific forest, but of the forest.

The extent to which artists relied on the aesthetic innovations of the Mughals depended on the extent to which their courts had rejected or accepted Mughal influences. Some states, such as Mewar and Malwa in southwestern Rajasthan, fiercely opposed Mughal power and culture. The images painted there, consequently, have more in common with indigenous folk painting. The large areas of bright color, simple architectural setting, and small, rather stiff figures of the Malwa painting *Futility of Meeting the Loved One through a Portrait* (p. 36) clearly demonstrates this. On the other hand, many courts, especially those close to the centers of Mughal power in Agra and Delhi, openly adopted Mughal cultural and artistic ideals. For example, *Kamodinī Rāginī* (p. 62) shares many features with Mughal painting. These are seen in the woman's large, well-articulated body, her carefully studied facial features, the subtle use of varying shades of color throughout, and the artist's attention to the descriptive details of the *rāginī's* garments, hair, and jewelry.

The impact of Mughal painting on the Rajput states was particularly strong during the eighteenth century, as the Mughal court grew less able or willing to support its artists. By 1739, when Nādir Shāh, a Persian invader, sacked Delhi and carried off the famous, jewel-encrusted peacock throne built for Shāh Jahān (r. 1628–58), artists had already begun seeking employment outside the Mughal court. Some found their way to Rajasthan. The majority, however, went either to provincial Muslim states, such as Oudh and Lucknow, or north to the Rajput courts of the Punjab. These artists brought with them Mughal skills and techniques perfected during the seventeenth century, as well as a taste for portraiture and historical scenes. These qualities soon were tempered by local preferences, though, and new modes of painting quickly developed. *Sohnī Crossing a River at Night to Meet Mahīnvāl* (p. 34), with its carefully studied and drawn figures, well-composed landscape, and ingenious use of blues and greens to create an eerily quiet setting, is typical of provincial Mughal painting. Although the formal treatment of the image is extremely close to Mughal work (the artist may have trained at the Mughal court), the theme of the miniature, taken from a local Hindu folk tale, reflects an interest in provincial culture that was no longer a major concern of the court at Delhi.

In the Punjab hills the transmission of Mughal influences is more complicated. A number of areas remained hostile to Mughal forms and concepts, as did Rajasthan, though they did accept some Mughal subject matter. The striking portrait of a nobleman from Mankot (p. 66) is typical of these courts. Unlike comparable Mughal portraits, which depend on the subtle depiction of facial features and movements of the body for primary effect, this miniature depends almost entirely on the interplay of its colors. The artist has set the nobleman's bright red robe against his purple turban and slippers and the green background to produce a slightly uneasy and constrained mood. One immediately senses the man's primness, a characteristic evident in his neatly manicured hands and smugly drawn mouth. Although the artist has assimilated the use of shading and other techniques of naturalism for descriptive purposes, such as articulation of the nobleman's eye and chin, these remain secondary concerns.

A far more pronounced response to Mughal forms can be seen in the paintings from the Kangra Valley, particularly Guler. The prince's face in *Prince with Huqqa* from Guler (p. 68), with its well-trimmed beard and sharp, strongly defined nose, is almost Mughal in its extraordinary characterization. Unlike the painting of the nobleman from Mankot, in which line and modeling are suppressed by the expressive force of the colors, here they take on a primary function. The composition, with its three-dimensional space and distinct architecture, is also dependent on Mughal sources.

There is, however, much more to the paintings of Guler than the simple borrowing of Mughal forms and techniques. The descriptive principles of Mughal painting, which are usually concerned with the accurate portrayal of individual figures and scenes, were used by the hill artists to infuse their work with lyrical sentimentality and beauty. As a result, the techniques of naturalism, which had become ends in themselves under the Mughals, were given new meaning. Line, color, and modeling were no longer used only to suggest individuality, but to create general types that in spirit and conception are entirely Hindu. Women, for example, tend to be tall and graceful, with long curving backs, soft black hair, and perfectly formed, almond-shaped eyes. This is as true for the princess and her maid in *Prince with Huqqa* as it is for the woman in *Nāyikā with Deer* (p. 72). In both, the women's idealized beauty is meant to evoke the beauty of classical Indian figures like Urvashī, one of the heavenly nymphs found in the *Mahābhārata*.

13

(a) Kālaka Hears Gunākara Preach/ Kālaka on His Horse
(b) Kālaka Complains to King Gardabhilla

from a manuscript of the Shrīvīravākyānumatam version of the *Kālakācāryakathā*[1]

Western Indian style, third quarter 15th century
(a) 11 x 7.5 cm painting; 11 x 25 cm page
(b) 11.1 x 7.4 cm painting; 11.1 x 27 cm page
Gifts of Alexander H. Bullock, 1952.10,11
Ex. coll.: Heeramaneck Galleries, N.Y.

(a) In the upper register, Kālaka sits under a tree, with hands folded in reverence, listening to his master, Gunākara, preach. Between them is a stand symbolically representing Gunākara's absent teacher. In the lower register, Kālaka on his horse is accompanied by an attendant with shield and sword.

(b) Kālaka, now in monk's robes, stands before King Gardabhilla protesting the abduction of his sister, Sarasvatī. The bearded king, in black print trousers, sits on a footed throne under a parasol. Overhead are decorative niches.

These two successive leaves are from a manuscript of the most popular version of the *Kālakācāryakathā*, or Story of the Teacher Kālaka. The *Kālakācāryakathā* is a non-canonical Jain text, which, for a number of reasons,[2] usually appears at the end of the *Kalpasūtra*, a life history of Mahāvīra, the founder of Jainism. The paintings on these two pages are good examples of the Western Indian school, a conservative style whose main features were developed by the end of the thirteenth century:[3] gold figures against a brick red ground with the lavish addition of ultramarine; thin, wiry lines and vigorous, meticulous gestures, which give each figure a pert, eager look; the protruding eye, which conventionally juts out when the figure is not full face (detail); and an almost total absence of natural landscape. Western Indian painting is, in general, a formal art with a highly decorative quality. There are only rare attempts at portraiture; as seen here, figures are drawn from idealized types.

The verses on these two leaves recount an incident from the early part of Kālaka's career.[4] They tell of the saint's visit to Ujjain with his sister; her abduction by King Gardabhilla; Kālaka's protest and the king's rebuff; Kālaka's complaint to the community and their protest and rejection; and Kālaka's denunciation of the king.

"Now, the nun [Sarasvatī] [begin leaf a] had also gone with them to this foreign place and was seen there by the king. She was so beautiful and so virtuous, that even Kāma [the god of love] seemed a horrible corpse in comparison. All of a sudden, her brother, the holy teacher Kālika, the master of Jain teaching, [heard] her cry out: 'Save me from being taken away from my own home by Gardabhilla, the vilest of kings!' Shouting this, the virtuous woman was abducted from her own home by the evil prince and his men.

"Discovering what had happened, the sage, whose virtues were known throughout the land, became loud and angry. The holy guide and teacher Kālika went before the king and announced his wish to the sovereign, its argument laid out long ago: 'O King! Release this woman, my sister! She is bound by a religious vow! Any other man with such an evil mind and bad character would be punished by you immediately. You should not bring shame to [our] race by [relinquishing] your own path for another, for this truth still lives. [According to the proverb], "You town-folk should never be a part of the forest." Wherever the king is his own thief and wherever he is his own priest carrying the sacred vessel around, from this [king] [begin leaf b] who once gave shelter, fear is now born. In fact, the numerous daughters of [other] kings, handsome ladies too, are never in your women's compound. So release my sister immediately, whose dress is old and dirty and who is weak from austerities!' Numbed by the speech of the greatest of sages, the king did not speak at all.

"The illustrious, holy teacher Kālika then [went] before the Community [of monks and nuns], who were still unaware of the incident. Whereupon, the Community spoke [further] strong words in the presence of the council of the king: 'O King! This wicked deed is not yours to do, O Lord!, for you rule the world like a father.' Although the Community spoke loudly and with purpose, the great ruler still did not release the virtuous woman.

16

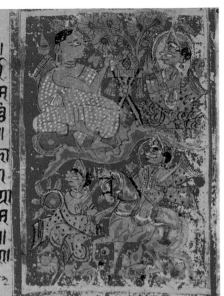

(a)

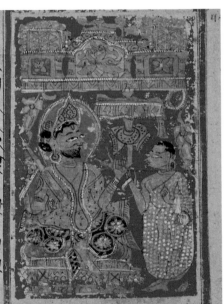

(b)

"Overcome with anger, the supreme sage made this vow: 'All those who are hostile to the teaching of the Jina and whose speech is vicious towards the Community, holding views which are indifferent and heretical, against them I move continuously from now on—such that I do not allow this dangerous King Gardabhilla to grow in wealth, in sons, or in sovereignty.' Being one who abides by an agreement with a subject and now moved toward conformity with this vow, the king, holy Gardabhilla, wandered everywhere throughout the great city, his limbs smeared with mud, muttering, and thereafter [renouncing] his delightful compound of women."[5]

[1]Another leaf from this manuscript is in the Brooklyn Museum of Art.
[2]W. N. Brown, *The Story of Kālaka* (Washington: Freer Gallery of Art, 1933), pp. 1–2; for paintings similar to ours see also p. 134, fig. 23; p. 136, fig. 26; p. 142, fig. 35.
[3]*Barrett and Gray*, p. 55. For further examples of Jain painting, see W. N. Brown, *Miniature Paintings of the Jaina Kalpasūtra* (Washington: Freer Gallery of Art, 1934).
[4]Beginning with verse 10 on leaf a through the first part of verse 21 on leaf b.
[5]As no translation of the text was available, I made my own, using also the edition published in Brown, *The Story of Kālaka*. His text and that on our two leaves compare favorably, with only minor differences.

Literature:
Heeramaneck, nos. 37B, D (B as *Kalaka receives his parents' permission to become a monk*, and D as *Kalaka exercises the horse, Kalaka hears Kunakara preach*).
WAM 1953, pp. 11–12 (illus.) (1952.10 as *Kalaka Exercises the Horse; Kalaka Hears Gunakara Preach;* 1952.11 as *Kalaka Remonstrating with King Gardabhilla about the Abduction of his Sister, Sarasvatī*).
WAM Annual Report 57 (1953): xii (1952.10 as *Leaf of a Manuscript of the Kalakacarya Katha;* 1952.11 as *Leaf of a Manuscript of the Kalpasutra*).
Objects.

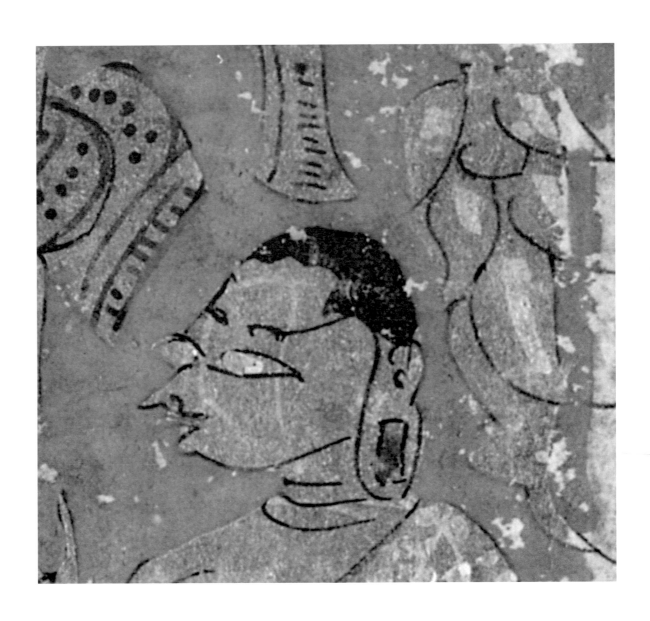

Detail of *Kālaka Complains to King Gardabhilla*

Warriors on Horseback

from a manuscript of the *Khamsa* by Amīr Khusrau Dihlavī (1253–1325)[1]

Sultanate, Delhi, mid-15th century
12.4 x 20.8 cm painting; 33.5 x 23.5
cm page
Museum purchase, through Jerome
A. Wheelock Fund, from Demotte,
Inc., N.Y., 1935.22

Led by two mounted figures in full-armored dress, opposing armies of warriors on horseback meet face to face under a cloudburst.

An Indian poet of Turkish ancestry, Dihlavī modeled his *Khamsa,* or "quintet" of tales, on the *Khamsa* of Nizāmī, a famous Persian poet.[2] Although Amīr Khusrau himself admitted he had not achieved the excellence of Nizāmī, his *Khamsa* is nevertheless one of the great works of Persian literature, as popular in India as in its native land.[3]

The origin of Sultanate painting is unclear. Ettinghausen has suggested some influence from fourteenth-century Egyptian miniatures, particularly in the restricted color scheme, the lack of "exuberant tree-like plants," and the almond-shaped eyes.[4] Others have suggested that local Indian painters in Delhi, having been taught by artists imported from Shiraz, followed Persian models, particularly in the use of the square jaw and the big, broad face.[5]

In any case, the squarish heads, solid background, bold palette, and pictorial directness are standard elements in Sultanate painting. What makes this miniature rare, however, is its peculiar vibrancy and composition and the use of narrow slices of color in the sky. Interesting as well are the two main figures, who go almost unnoticed as their dark blue and green clothes blend imperceptibly into the dark green ground. Instead it is the groom in the center and the second man in each army, all dressed in red and white, who first draw our attention. The pictorial violation of margins—with banners extending boldly into the text—is also typical of Sultanate painting, especially when, as in other pieces from this period, the artist has chosen not to compartmentalize the picture.[6]

[1] See *Binney: Mughal,* cat. 1a-b, for discussion on the whereabouts of other leaves; and B. B. Johnson, "A Preliminary Study of the Technique of Indian Miniature Painting," in *Aspects of Indian Art,* ed. P. Pal (Los Angeles, 1970), pl. 84, for a detailed reproduction of one of the pages.
[2] See B. W. Robinson, "The Earliest Illustrated Manuscript of Nizāmī?," *Oriental Art,* n.s. 3, no. 3 (Autumn 1957): 96–103. On material from the same era, see B. W. Robinson, "The Tehran Manuscript of *Kalīla wa Dimna,*" *Oriental Art,* n.s. 4, no. 3 (Autumn 1958): 108–115; and R. Skelton, "The Ni'mat nama: A Landmark in Malwa Painting," *Mārg* 12, no. 3 (1959): 44–50.
[3] "Homāge to Amir Khus'rāu," *Mārg* 28, no. 3 (June 1975): 8.
[4] R. Ettinghausen, *Paintings of the Sultans and Emperors of India in American Collections* (New Delhi: Lalit Kalā Akademi, 1961), pl. 1.
[5] N. Titley, "Persian Miniatures of the 14th, 15th, 16th Centuries and Its Influence on Indian Painting," *Mārg* 28, no. 3 (June 1975): 14; also see p. 20 of the same volume; *Binney: Mughal,* pp. 15–16. For more on this tradition, see S. Digby, "The Literary Evidence for Painting in the Delhi Sultanate," *Bull. of the American Academy of Benares* 1 (1967): 47–58.
[6] *Binney: Mughal,* cat. 1a-b.

Exhibitions:
Philadelphia Museum of Art, Philadelphia, October 1926, no. 186
Fogg Art Museum, Cambridge, Mass., December 1929–February 1930
Renaissance Society of the University of Chicago, 10 November 1930
The Art Institute of Chicago, March 1932–1933

Literature:
WAM Annual 1 (1935–36): 38, 46, 48 (illus.).
Objects.

می کردیسنان بچشم باریک جاسوسی سینهای اریگ

ابروی کمان کرشمه انگیز ناو کلکش چو غمزه تیز

مرگ ام وجان زسینه میرود بر نغمه تیرپای می کوفت

شمشیر کشیده مرد دلیسا نوفل بیان جو تند شیری

ز ان کینه کبی در یغ میرفت یک منفته دوریه تیغ می

کفته باتفاق پیران در سوخته به در خانه ویرا

افت زجهان چو کشت کم ام غوغانی دوسوی کیر ارام

همسله مجنون ان ران بد سوخته درونه پرداز

در غزی که شنیده بود نهفت یکریت نخت و بعد ازان کفت

سو میرسپه دوید جوشان جون سیل که میرسد خروشان

وان تیر که خون حلال میکرد پی را بجگر نهال میکرد

پیکان بجگر شکاف میکرد دست میداد زبان ودل همی برد

بر اسم عرب بجهد ونا ددد میکرد ستیزه مرد با مرد

هرسو که نکلت تیغ بولاد کردان هرم درکردن ازاد

خلعتی سوی لعبت حصاره تنگ امده ز ان ستیهر

خیریم مشک زخون سیله در خاک دوان کبنر سیله

سم زخنه فتنه بسته کرد سم دل زکر نذر بسه کرد

آمد سوی ان مشتم وسید نالید زبان غم سبید

مجنون که ازان خبره شد اگا برو زدرون دل لکی آه

یکرفت عنان از کبش بخت می سوخت زخام کار زبه

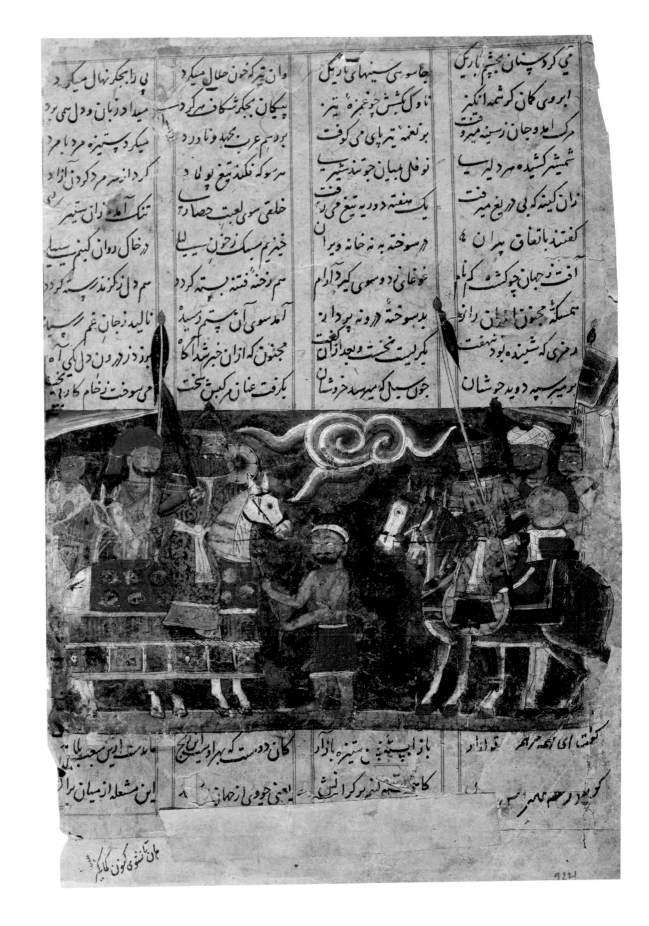

گشت ای لحه جمر امهر تو ازاد باز ابه پینه و ستیزه بازار کان دوست که بهرا ویلیج ماد رست ازین سجب یلا

کو بدو رحم ایمهر سم کا تیم لنه برکر انش یعنی خودی از جهانش این مشعلها ازمیان برا

Birth of Ghazan Khān

from a manuscript of the *Jāmi'-al-Tawārīkh* by Rashīd al-Dīn (1247–1318)[1]

Mughal, ca. 1596
Designed by Basāwan, executed by
Bhīm Gujerati, faces by Dharm Dās
35.6 x 22.2 cm painting; 37.9 x 24.3
cm page
Museum purchase, through Jerome
A. Wheelock Fund, from Demotte,
Inc., N.Y., 1935.12

As a nursemaid displays the newborn
Ghazan Khān to his mother, attend-
ant ladies converge on the nativity
with gifts. Outside the harem walls,
courtiers gather and astrologers cast
a most auspicious horoscope. In the
lower court, retainers busily prepare
for the birth festivities, and raucous
music fills the street.

The inscriptions read:

"In the eleventh month of the year of the monkey in Absukun in the province of Mazandarin with a good ascendant in Scorpio…Ghazan Khān placed his royal foot from the hiding place of non-existence into the goodness of existence and the eye of the world was illuminated by his beauty. And the group of great astrologers who were present read the planets and the situation of his blessed birth, and using all caution they cast his horoscope and found the ascendant of his birth extremely favorable.

"And each of them said, ['I have looked into your ascendant, your lot will be that of one thousand lives.'] And they were all in agreement that he would be a great king. [And they shouted,] 'His ascendant and his lot are lofty. May his throne reach the shining sun.' They gave him to a well-mannered wet nurse.…"[2]

Mughal painting came into its own under Akbar, emperor from 1556 to 1605, with historical scenes such as this. The events Akbar thought most suitable for immortalization in a miniature were often battles and births,[3] for they were not only momentous and lively occasions, but also what most made an empire. This painting depicts the birth of Ghazan Khān (r. 1295–1304), son of Arghoun Khān (r. 1284–91), a Mongol sultan of Persia.

Akbar was a descendant of Genghiz Khān through his grandfather Bābur's mother. With manuscripts such as this, which was illumined for the emperor in Delhi, Akbar sought to illustrate his noble heritage and further legitimate his rule. The *Jāmi'-al-Tawārīkh* manuscript was originally commissioned by Ghazan Khān's successor, Uljaytu (r. 1304–16), as a general history of the world as it was known by the Mongol court. The first of its four volumes, from which this probably comes, was a record of monumental events in the history of the Turk and Mongol tribes.[4]

All three artists who worked on this miniature were leading court painters under Akbar, but the greatest was Basāwan,[5] one of the emperor's two most esteemed Indian masters. Basāwan is especially noted for compositions that explore the effects of deep space,[6] particularly as it recedes through the various courts and antechambers, taking the viewer's eye from one vibrant center of activity to another. This he effectively does by making the design a scheme of ascending diagonals, drawn from an aerial viewpoint. Basāwan's figures, moreover, are well-rounded, giving a strong sense of substance under their ample clothing,[7] and they are enhanced by lively and flamboyant gestures and brilliant colors. As in many paintings from the Akbar period, each figure depicted here is an individual, with his character shown most prominently in the rendering of face and posture.

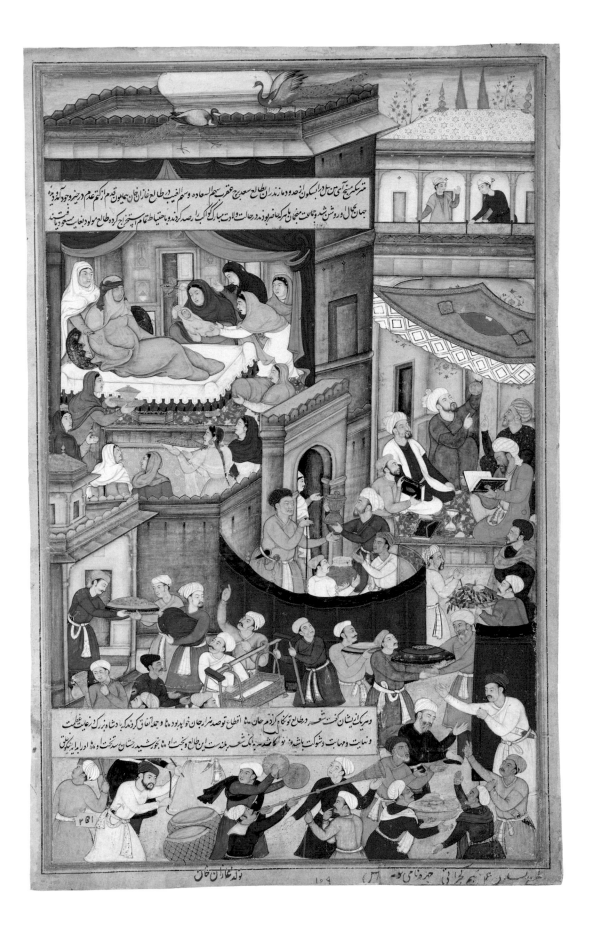

Adorning the straightforward depiction of the birth are delightful details: the shy lady in white appearing at the door to tell the particulars of the birth (detail a), the gold cradle arriving at the lower door (detail b), the gold incense burner swung by the nursemaid in blue, and the duo of auspicious peacocks stalking the roof.

[1] This is one of the few dispersed leaves from the *Jāmi'-al-Tawārīkh*, the bulk of which is in the Gulistan Library in Teheran. For a discussion of other leaves, see *Binney: Mughal*, cat. 17; and B. B. Johnson, "A Preliminary Study of the Technique of Indian Miniature Painting," *Aspects of Indian Art*, ed. P. Pal (Los Angeles, 1970), pl. 81.

[2] At the bottom of the painting the following inscription also appears: The birth of Ghazan Khān, designed by Basāwan, executed by (Bhī)m Gujerati, faces by Dh(arm) (Dā)s. My thanks to M. Wheeler Thackston of Harvard University for his translations.

[3] Cf. *The Birth of Jahāngīr* in *Beach*, no. 15; *Welch 1978*, pl. 16; A. K. Coomaraswamy, *Catalogue of the Indian Collections in the Museum of Fine Arts, Boston*, pt. 6: *Mughal Painting* (Cambridge: Harvard University Press, 1930), pls. 3–6; S. C. Welch, *The Art of Mughal India* (New York: Asia Society, 1963), pl. 26; and *Rejoicing at Fatehpur Sikri, on the birth of the Emperor Akbar's second son, Murad, in 1570*, in *Archer and Singh*, pl. 20.

[4] D. T. Rice and B. Gray, *The Illustrations to the 'World History' of Rashīd al-Dīn* (Edinburgh: Edinburgh University Press, 1976), pp. 1–2. See also J. Marek and H. Knížková, *The Jenghiz Khan Miniatures from the Court of Akbar the Great*, trans. O. Kuthanová (London: Spring Books, 1963), pp. 11–16.

[5] See W. Staube, "Contribution à l'étude de Basāwan," *Revue des arts asiatiques* 8 (1934): 1–18.

[6] *Beach*, p. 131; S. C. Welch, Jr., "The Paintings of Basāwan," *Lalit Kalā* 10 (1961): 12.

[7] *Beach*, p. 131.

Exhibitions:
Memorial Art Gallery, Rochester, N.Y., 1930
University of Pennsylvania Museum, Philadelphia, 1930
De Young Memorial Museum, San Francisco, 1931

Literature:
E. Blochet, *Catalogue of an Exhibition of Persian Paintings from the XIIth to the XVIIIth Cent. Formerly from the Collections of the Shahs of Persia and of the Great Moguls Held at the Galleries of Demotte, Inc.* (New York, 1929), no. 149.
W. Staube, "Basāwan," pl. 3, fig. 4, pp. 5, 14.
WAM Annual 1 (1935–36): 38, 46–48 (illus.).
WAM Annual Report 40 (1936): 12.
Objects.
Artists, Artisans, and Islamic Design, exh. cat. (Amherst: University of Massachusetts, 1972), p. 15.

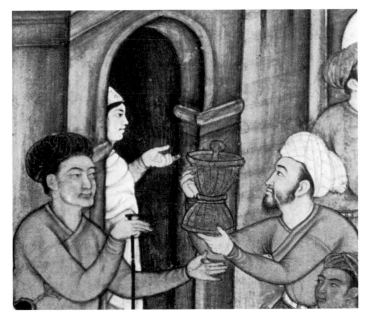

a Detail of *Birth of Ghazan Khān*

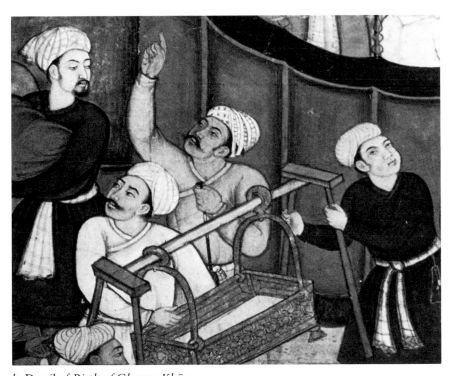

b Detail of *Birth of Ghazan Khān*

Mān Singh of Amber[1]

Mughal, ca. 1600
13.1 x 7.8 cm painting; 26.6 x 17.6 cm
page
Gift of Alexander H. Bullock, 1957.7

Wearing a transparent white jāma'
over pink paijāmas, *a gold* kamar-
band, *and red slippers, the portly
Mān Singh stands against a conven-
tional pale green ground.[2] Tucked
into his sash is a jeweled dagger, and
on his head a pale, flat turban.*

According to James Tod (1782–1835), an Englishman who spent many years in India, Mān Singh

"was the most brilliant character of Akbar's court. As the emperor's lieutenant, he was entrusted with the most arduous duties, ... and he became the most conspicuous of all the generals of the empire. To him Akbar was indebted for half his triumphs."[3]

Jahāngīr, however, Akbar's son and successor thought otherwise.

"He also ... is one of the hypocrites and old wolves of this State. ... The aforesaid Raja produced as offerings 100 elephants, male and female, not one of which was fit to be included among my private elephants. [However,] as he was one of those who had been favoured by my father, I did not parade his offenses before his face, but with royal condescension promoted him."[4]

Mān Singh (1535–1614) entered Akbar's service in 1562, when his grandfather by adoption, Rājā Bihārī Mall of Amber, was received at court and gave the emperor his daughter in marriage—in pursuance of the emperor's new policy to strengthen the state by marrying Hindus. Mān Singh subsequently proved an excellent general and added region after region—in particular, Orissa and Assam—to Akbar's empire. He was also a good administrator and oversaw the governments of Bengal, Bihar, the Deccan, and Kabul. Towards the end of his life, however, this most distinguished vassal of Akbar fell from favor, and Amber, over which he had become Rājā in 1592, lapsed into temporary obscurity. Sources differ as to where he died.[5]

Mān Singh's downfall stemmed from his own love of power. In 1605, when Akbar was on his deathbed, Mān Singh became involved in a plot to change the succession from the wayward Prince Salīm (the future Jahāngīr) to Salīm's own son and Mān Singh's nephew, Prince Khusrau. According to Tod, Akbar was familiar with the plot and is said to have prepared a refreshment called *ma'ajun,* making one part poison-ous. Akbar mistakenly ate the poison and, being already old and sick, died soon thereafter.[6] Tod's account, however, may be incorrect,[7] for there is no mention of this incident in either the memoirs of Akbar or Jahāngīr.[8]

This portrait of Mān Singh is but one of many Akbar had made of his nobles.

"His majesty himself sat for his likeness, and also ordered to have the likenesses taken of all the grandees of the realm. An immense album was thus formed: those that have passed away, have received a new life, and those who are still alive, have immortality promised them."[9]

The naturalism, fine execution, and psychological sensitivity of Mān Singh's portrait (detail) are typical of the style under Akbar. Here we see a strong man, fond of power, but especially vulnerable to the pleasures of this life.

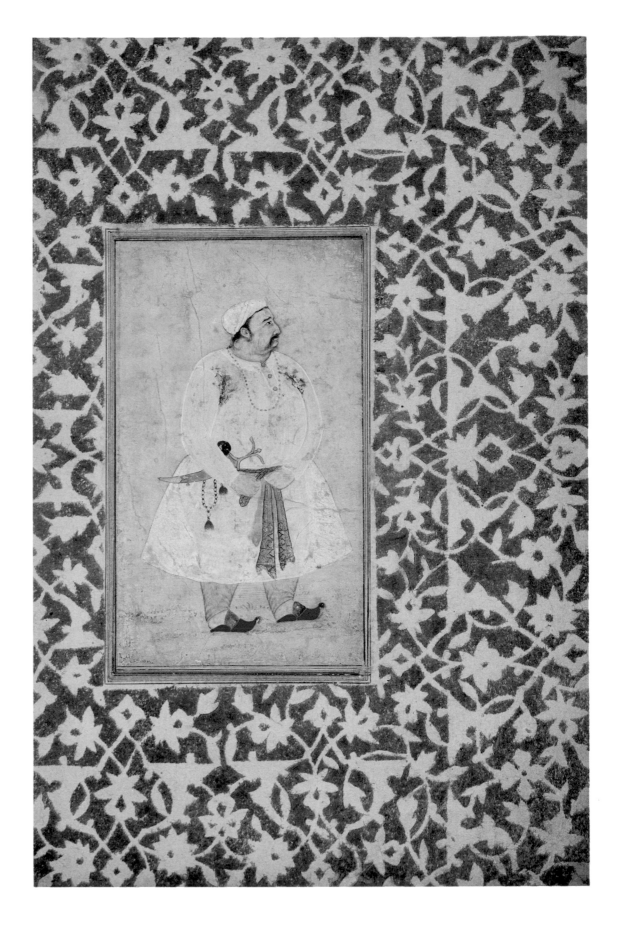

[1] I am grateful to Ellen Smart of the Rhode Island School of Design, Providence, for discussions about the merit of this identification. It is based upon the similarity of the portrait to another in the Museum of Fine Arts, Boston—itself identified as of Mān Singh on the basis of its resemblance to an inscribed portrait of the Rājā in the British Museum. Although the Worcester and Boston portraits are both early 17th-century Mughal, the British Museum portrait is late 17th century and its inscription even more recent. All three men are short and portly, but differ somewhat in profile and mustache. This may be because they are the work of different artists. For the Boston portrait, see A. K. Coomaraswamy, *Catalogue of the Indian Collections in the Museum of Fine Arts, Boston,* pt. 6: *Mughal Painting* (Cambridge: Harvard University Press, 1930), p. 37, pl. 28; and the British Museum portrait, A. K. Coomaraswamy, "Mughal Portraiture," *Orientalische Archiv* 3: fig. 12.

[2] S. C. Welch, Jr., "Early Mughal Miniature Paintings from Two Private Collections Shown at the Fogg Art Museum," *Ars Orientalis* 3 (1959): 139; S. C. Welch, Jr., "Mughal and Deccani Miniature Paintings from a Private Collection," *Ars Orientalis* 5 (1963): 221.

[3] James Tod, *Annals and Antiquities of Rajasthan,* 3 vols. (London: Oxford University Press, 1920), 1:391, 3:1338.

[4] *Tūzuk-i-Jahāngīrī* (London, 1909), p. 138.

[5] Tod, *Annals,* 1:391, 3:1338–39; and S. Bhattacharya, *A Dictionary of Indian History* (New York: George Braziller, 1967), p. 577.

[6] Tod, *Annals,* 1:408.

[7] F. Augustus, *The Emperor Akbar,* ed. G. von Buchwald and trans. A. S. Beveridge, 2 vols. (Calcutta: Thacker, Spink and Co., 1890), 2:421–25.

[8] H. Beveridge, trans., *The Akbarnāma of Abu-l-Fazl,* 3 vols. (Calcutta: Royal Asiatic Society of Bengal, 1939), 3:1258–62.

[9] Abu'l-Fazl 'Allami, *The A'īn Akbari,* trans. H. Blochmann (Calcutta, 1927), pp. 108–9.

Exhibitions:
WAM 1926
Chicago 1926

Literature:
WAM Annual Report 61 (1957): 13 (as *Portrait of Mān Singh*).

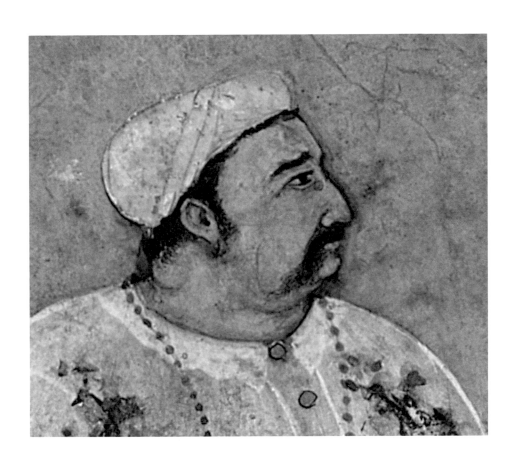

Detail of *Mān Singh of Amber*

Aurangzēb in Old Age

Mughal, late 17th century
18.1 x 11.1 cm painting; 24 x 16.9 cm
page
Museum purchase from Ananda K.
Coomaraswamy, 1926.5

Bent with age, Emperor Aurangzēb leans on a staff and fingers his rosary. He wears a pale yellow coat over a white jāma' *and narrowly striped* shalwār, *and on his head, a turban bound by a jeweled* mālā-band. *The pale green ground is without detail except for the gradual transition from dark green grass to bright blue sky.*[1]

The third son of Shāh Jahān, Abū'l Zafar Muhi-ud-dīn Muhammad Aurangzēb 'Ālamgīr (r. 1658–1707) was the sixth and last of the great Mughal emperors. His rise to power and consolidation of loyalties was the successful result of treacherous battles against his brothers, particularly against Dārā Shikōh, the eldest and heir apparent. Formally crowned in June of 1659, Aurangzēb later conquered the Deccani sultanates of Bijapur and Golconda, thereby extending the boundaries of the Mughal empire southward and, as it turned out, beyond effective control. He was a zealous Sunni Moslem and, unlike his religiously tolerant ancestors, sought to rule by strict Qur'ānic law. Orthodox to the point of bigotry, he imposed restrictions on food, drink, and dress and harshly persecuted his normally supportive Hindu subjects.[2]

Aurangzēb's increasing adherence to an orthodox interpretation of Islam led to his gradual withdrawal of royal patronage from many of the arts, including painting. Nevertheless, likenesses of him in old age, such as this delicate and refined version,[3] are common and similarly rendered, indicating that paintings were still produced despite the reduction in royal ateliers.[4]

This portrait of Aurangzēb shows a bent over, profoundly sad and wasted man, reflecting, perhaps, on the events in the Deccan (where he was quite often in old age and where this work may have been painted), or regretting the deeds of his youth. The iconography is typical, for the aged Aurangzēb is usually shown with some mark of his faith: rosary, text, or folded hands.[5] The clarity and precision of the emperor's figure contrast sharply with the vague emptiness of the background, creating, perhaps intentionally, an air of solitariness.

[1] A. K. Coomaraswamy, "Notes on Indian Painting," *Artibus Asiae,* no. 2 (1927), pp. 132–33, fig. 6. See *Coomaraswamy 1926,* pp. 23–38, for further discussion of costume.
[2] S. Bhattacharya, *A Dictionary of Indian History* (New York: George Braziller, 1967), pp. 81–84.
[3] Coomaraswamy, "Notes," p. 132.
[4] N. B. *Binney: Mughal,* pp. 89–95, esp. cat. 69b; *Welch 1978,* pp. 29–30, pls. 37–38.
[5] *Binney: Mughal,* cat. 69b; *Chandra,* no. 30; B. Gascoigne, *The Great Moghuls* (New York: Harper & Row, 1971), p. 239; K. Khandalavala, *Pahārī Miniature Painting* (Bombay: New Book Company Private Limited, 1958), no. 99, p. 103.

Exhibitions:
WAM 1926
Chicago 1926

Literature:
WAM Bulletin 17, no. 1 (April 1926): 16 (illus.) (as *Portrait of Aurangzeb*).
WAM Annual Report 31 (1927): 32 (as *Portrait...*).
Coomaraswamy, "Notes," pp. 132–33, fig. 6 (as *Aurangzīb*).
Objects (as *Portrait...*).

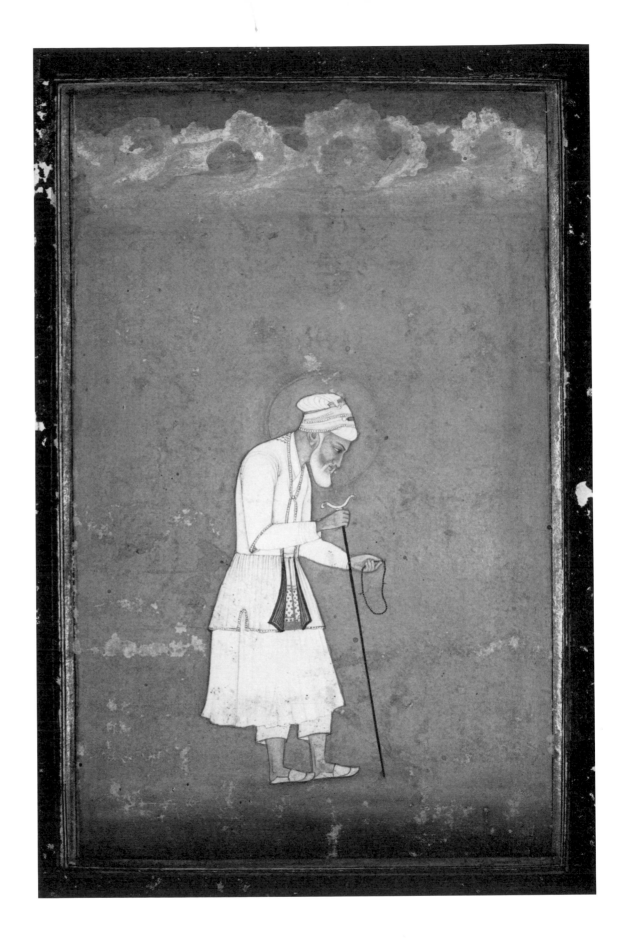

ʾAlī ʾĀdil Shāh II

Deccan, Golconda, ca. 1670
27.6 x 17.1 cm painting; 37.3 x 25.7 cm
page
Gift of Alexander H. Bullock,
1958.42

*Surrounded by ornamental flora, the
sultan stands in his garden smelling a
flower. He is dressed simply, in a
green* jāmaʾ, *dark blue shawl, and red
turban and is protected from the
ground by a dark brown stool under
his feet.*

ʾAlī ʾĀdil Shāh II (r. 1656–72) was the eighth sultan of the ʾĀdil Shāhi dynasty of
Bijapur. He was only eighteen when he ascended the throne and, because of his
youthful vulnerability, was immediately attacked by Aurangzēb, son of Emperor
Shāh Jahān and then viceroy of the Mughal Empire in the Deccan. The armies of ʾAlī
ʾĀdil Shāh were defeated, and he was forced to purchase peace with the Mughals by
surrendering a large portion of his territories. In 1659 the sultan sent a new army
against the Maratha leader Shivaji, but again met defeat. During the rest of ʾAlī ʾĀdil
Shāh's troubled reign and that of his successor, Sikandar (r. 1672–85), Bijapur
became weaker and weaker until it was conquered by Aurangzēb in 1685.[1]

Although the inscription above the painting reads "Tānā Shāh, ruler of [the city]
Hyderabad" (i.e., Abūʾl Hasan, Tānā Shāh, of the kingdom of Golconda), it is
incorrect.[2] Mark Zebrowski has correctly identified our king as ʾAlī ʾĀdil Shāh II.[3]
Although slightly effaced, the king's features and dark complexion are identical to
those in a portrait painted in Bijapur around 1660 and published by D. Barrett as ʾAlī
ʾĀdil Shāh II.[4] Stylistic features, particularly the luxuriant foliage, place this work in
Golconda rather than Bijapur; but this is not unusual, for Golconda artists often
painted portraits of rulers of neighboring states.

This is a late, but very fine, example of Deccani portraiture, dating just a decade and
a half before Aurangzēb completely conquered the Deccan and brought to an end its
distinguished tradition of painting. Typical of the period in general are the painting's
design and ornate detail. And typical of Golconda in particular are the rich two-
dimensional surface, the extravagant use of gold on a purple background, and the
careful symmetry of the delicate floral design on the sultan's green *jāmaʾ*. The deep-
rose nimbus around his head is similar to those used for Mughal emperors, and the
flower pose is often found in portraits of noblemen from this region.[5] Despite the
finely executed naturalism of his face, ʾAlī ʾĀdil Shāh has an unusual stiffness. This is
balanced, however, by the gentle, but exuberant, sweep of the lily and willow and the
muted, but glowing, palette.

[1] S. Bhattacharya, *A Dictionary of Indian History* (New York: George Braziller, 1967),
pp. 31-32. See also B. Gray, "Deccani Paintings: The School of Bijapur," *Burlington
Magazine* 73 (1938): 74-76.
[2] Cf. the portrait of Abūʾl Hasan Qutb Shāh in *Binney: Mughal*, cat. 137, pp. 162, 166.
[3] I am greatly indebted to Mark Zebrowski for this information. The Worcester por-
trait will appear in his forthcoming book, *Painting of the Deccan*, to be published by
Sotheby Parke Bernet, London.
[4] D. Barrett, "Some Unpublished Deccan Miniatures," *Lalit Kalā* 7 (April 1960):
8,13. See also D. Barrett, "Painting at Bijapur," in *Paintings from Islamic Lands*, ed.
R. Pinder-Wilson (Oxford: Bruno Cassirer, 1969), pp. 142-59.
[5] Cf. *Binney: Mughal*, cat. 132, 134, 136a, 137.

Exhibitions:
WAM 1926
Chicago 1926

Literature:
WAM News Bulletin and Calendar 24, no. 5 (February 1959): 17, 20 (illus.) (as *Abu'l
Hasan Tana Shah*).
WAM Annual Report 63 (1959): ix.

تاہ شاہ والی حیدر آباد

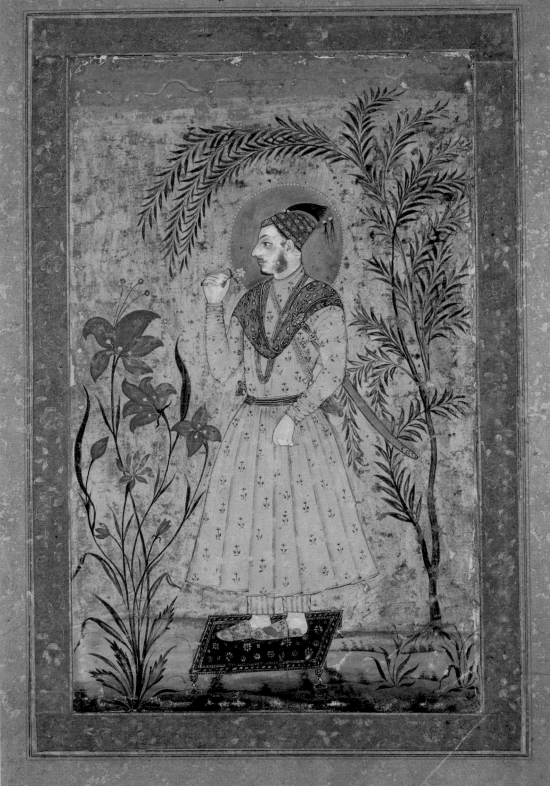

Sohnī Crossing a River at Night to Meet Mahīnvāl

an illustration to a Punjabi folk tale

Provincial Mughal, Lucknow (?), ca. 1770[1]
20.6 x 14.1 cm painting; 30.5 x 19.8 cm page
Gift of Alexander H. Bullock, 1953.80
Ex. coll.: H. Khan Monif

Under a full moon, Sohnī swims across a river to her lover, Mahīnvāl, who sits on the opposite shore playing a flute. Beside him, buffalo graze on the nighttime hills, and on the near bank a wise man meditates as he smokes a huqqa.

According to the tale, Sohnī loved Mahīnvāl, a herder of buffalo. Because they lived on opposite banks of the river, Sohnī crossed the river every night, using an inverted earthen pot as a float. Her brothers soon discovered the secret love affair, and thinking the alliance dishonorable because the lovers were of different backgrounds, they substituted a pot of unbaked clay for the one Sohnī always used. When she crossed the river that night, the pot disintegrated and Sohnī drowned.[2] The figure of the wise man in the tale is unclear, but he may be symbolic of *dharma* ("law," "duty"), which the two lovers violated by their affair. Although some interpret Sohnī's journey to Mahīnvāl as a soul's quest for God,[3] it is more likely the painting simply warns against illicit love.

Because this is an illustration of an oral folk tradition, for which we have no text except what was recorded by travelers in their diaries of local lore, we are at a loss to verify the exact origins of the painting. There are, however, similar miniatures, and from them we can assume this was probably painted for a late-Mughal patron who, like many of his contemporaries, was intrigued by local culture, particularly romantic sagas. Illustrations of oral folk tales like this one are often conservative in their preservation of iconographic elements,[4] but create, nonetheless, an unusual air of enchantment with their careful use of line and color.

Provincial Mughal painters at courts such as Lucknow owe their delicate drawing and fine modeling of the human figure, skillful shading of textile folds, and realistic rendering of landscapes to the influence of Mughal naturalism.[5] The composition of this painting is reminiscent of the earlier Mughal "scheme of overlapping diagonals,"[6] as it takes the eye up and down, from the wise man's glowing pink robes to the translucent ivory skins of the lovers. The dreamy landscape and subtle, yet powerful, colors—punctuated only by the bright orange red of swords, feet, and jewelry—further enhance the miniature's romantic mood.

[1]*Binney: Mughal,* cat. 100; cf. *Welch and Beach,* pl. 64; and *Ebeling, Rāgamālās* nos. 94–97.
[2]K. Khandalavala, *Pahārī Miniature Painting* (Bombay: New Book Company Private Limited, 1958), p. 46; *Coomaraswamy 1916,* 1:64.
[3]Marylin Rhie, *The Bodhisattva and the Goddess,* exh. cat. (Northampton: Smith College Museum of Art, 1980), pp. 60–61.
[4]Cf. *Coomaraswamy 1926,* p. 118, pl. 35; *Binney: Mughal,* cat. 105.
[5]*Ebeling,* pp. 44, 214.
[6]S. C. Welch, Jr., "The Paintings of Basāwan," *Lalit Kalā* 10 (1961): 12.

Exhibitions:
WAM 1926
Chicago 1926
Smith 1980

Literature:
Objects (as *Ranjha Swimming across a Stream*).
WAM 1953, p. 11 (as *Ranjha Swimming across a Stream to Visit Her Lover*).
WAM Annual Report 58 (1954): ix (as *Ranjha Swimming across a Stream to Visit Her Lover*).

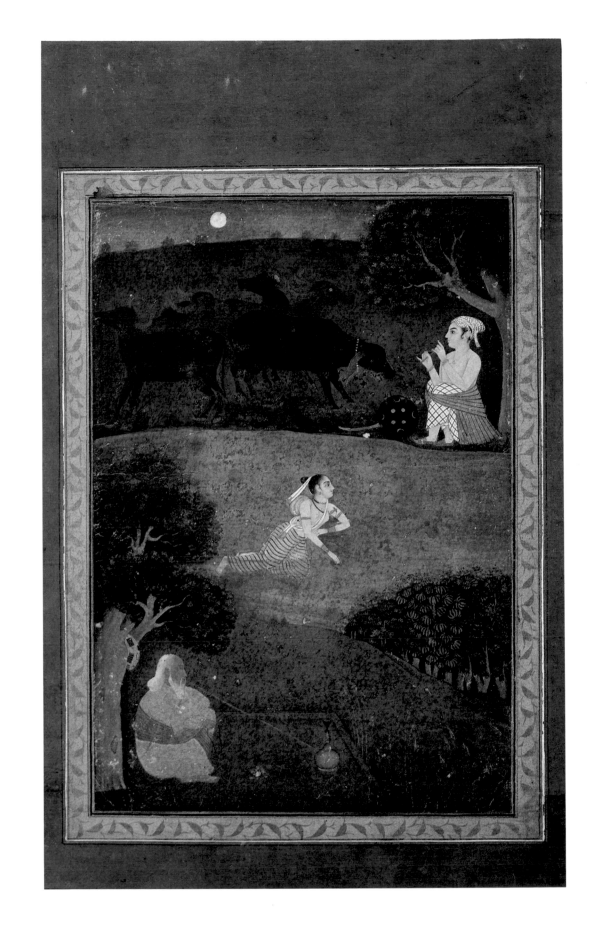

The Futility of Meeting the Loved One through a Portrait[1]

from a manuscript of the *Rasikapriyā* of Keshavadāsa[2]

Central India, Malwa, dated 1634[3]
10.6 x 13.7 cm painting; 20.3 x 16 cm page
Gift of Alexander H. Bullock, 1953.57
Ex. coll.: Heeramaneck Galleries, N.Y.

As two deer prance outside and a monkey climbs the turret on the roof, a friend (sakhī) *explains to Rādhā the lack of satisfaction in meeting Krishna through a portrait.*

Written in 1591, the *Rasikapriyā* is the most authoritative Hindi text on rhetoric and literary analysis. Using Rādhā and Krishna as its ideal lovers, the text categorizes the *nāyikā* ("heroine" or "soul") in the various stages of separation or union with the *nāyaka* ("hero" or "God"). Each part of this standard sequence of love is revealed through circumstance, character, emotion, and expression.[4] The text above and below explains the painting according to these love categories and, thus, it is only through the text that the painting, and in particular the rendition of the human figures, can truly come alive.

Here, a friend arrives and admonishes Rādhā for thinking she can achieve union with Krishna through his likeness.

"How can you remove the darkness by simply thinking of lighting a lamp with your love-condition [or oil]? Can anyone's hunger be appeased by showing food? Oh Queen! Can thirst be quenched by tales of water? Oh moon-faced, lotus-eyed friend! By drawing Lakshmi's pictures can wealth be obtained in a temple? Oh foolish girl, in the same way you are wasting your time. How can you have the satisfaction of meeting your lover by just looking at his portrait?"

According to the friend, aesthetic experience is fundamentally different from spiritual experience. While aesthetic rapture arises from a specific image, spiritual rapture (Rādhā's union with Krishna), though often dependent upon an icon, is possible only when God is present.[5]

As one of the first series of Malwa paintings produced after the sack of Mandu by Mughals three-quarters of a century earlier, the 1634 *Rasikapriyā* is among those that set the style of later Malwa painting. The compartmentalized composition, simple arrangement of figures, and flat ground of rich, solid colors are among the major features of this school. There are other idioms evident in this work, however, that are common to these early pieces: the flat expanse of scarlet ground, which lends power to the scene; the use of solid green to separate exterior from interior; the fishbone border; the wavy, white line outlining the sky; and a certain "heavy-chinned, scowling" look to the figures.[6]

The treatment of the figures and animals is what keeps the image from becoming static. The lively grace of the deer and monkey, the layered adornment of the women in jewels and flimsy veils, and the smaller-scaled Krishna in the portrait on the wall (detail)—all add vitality to the formal composition.

[1] I am indebted to Vishakha Desai of the Museum of Fine Arts, Boston, for her explanation of the iconography of this painting and for her translation of the text, which was made with the help of *The Rasika Priyā of Keshavadāsa*, trans. K. P. Bahadur (Delhi: Motilal Banarsidass, 1942), pp. 63–64.

[2] The *Rasikapriyā* was written in Orchha, Bundelkhand. This illustrated manuscript of the text is now dispersed, with the major portion, including the dated colophon, in the National Museum, New Delhi. On the whereabouts of the other leaves, see *Binney: Rajput*, p. 56; *Barrett and Gray*, p. 150; and E. McNear, *Indian and Persian Miniatures from the Collection of Everett and Ann McNear*, exh. cat. (n.p., 1967–68), no. 8.

प्रियाजोनें प्रकास चित्रकर सजा के सो दासन डरसा दीपक स
जी इकौं सजो तिही की ध्यान तम तेज हिनसा इहैं पांति निसे
यो धोए रेनु काह की बुराति ऋणपानी की कहा नी रानी प्या
स को बुझा तिहै ॥ प्रस मेरी इद्र दषी इ दीवर नैनी लिपै इ दि

रा क्यों न फिर में ल वति सि ध्याइ है सो से दि न से से ही गा
व ति र वा रि कहा वी दु ने पे मित्र के मिल को ल जु र इ है

[3]*Binney: Rajput*, p. 56; and *Ebeling*, p. 40.

[4]See the discussions in A. K. Coomaraswamy, "The Rasikapriya of Kesava Das," *Bulletin, Museum of Fine Arts, Boston* 18 (1920): 50–52; and W. G. Archer, *The Loves of Krishna* (London: George Allen & Unwin, 1957), pp. 90–92.

[5]A. K. Coomaraswamy, *The Transformation of Nature in Art*, 2nd ed. (Cambridge: Harvard University Press, 1934), p. 135.

[6]*Barrett and Gray*, p. 150.

Literature:
Objects (as *Gopi Persuading Radha to Meet Krishna*).
WAM 1953, pp. 11–12 (as *Gopi [a herd girl] Persuading Radha to Meet Krishna*).
WAM Annual Report 58 (1954): ix (as *Gopi Persuading…*).

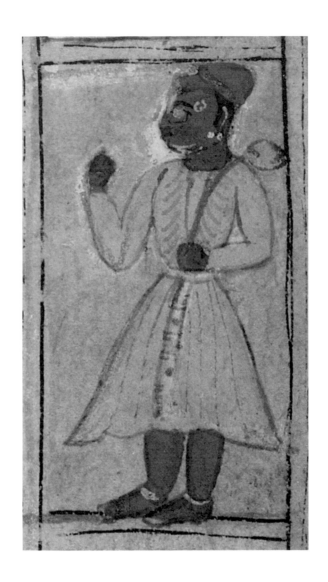

Detail of *The Futility of Meeting the
Loved One through a Portrait*

The Slaying of Vatsāsura[1]

from a manuscript on the life of Krishna

Central India, Malwa, ca. 1630–40
18.4 x 14.4 cm painting; 20.7 x 16.2
cm page
Gift of Alexander H. Bullock,
1954.152

Poised against a scarlet ground and
wearing the traditional yellow dhoti,
Krishna raises his right arm to slay
Vatsāsura, a demon (asura) *who has*
taken the form of a calf. On either
side, shaded by trees, the other
cowherds stand watching.

The story of Krishna slaying Vatsāsura, the calf-demon, comes from Krishna's late childhood, when he was allowed to join other young cowherds in the fields during the day.

"A cow demon, Vatsāsura, tries to mingle with the herd. The calves sense its presence and as it sidles up, Krishna seizes it by the hind leg, whirls it round his head and dashes it to death."[2]

By protecting his village through such feats of strength, the child Krishna revealed his divinity to the townspeople.

This is one of the earliest examples in which the standard idioms of Malwa painting can be defined. The central background of scarlet, the wavy, white line along the horizon, the stylized lollipop trees, and the perfunctorily drawn figures place this miniature at the beginning of the Malwa revival. Typical also is the liveliness of Krishna, for at this time the Malwa style was at its peak of energy and spontaneity.

[1]According to the inscription on the top panel.
[2]W. G. Archer, *The Loves of Krishna* (London: George Allen & Unwin, 1957), p. 33.

Literature:
Heeramaneck, no. 46 (as *Krishna Slaying the Asura* [demon]).
WAM Annual Report 59 (1955): ix (as *Krishna Slaying the Bull*).

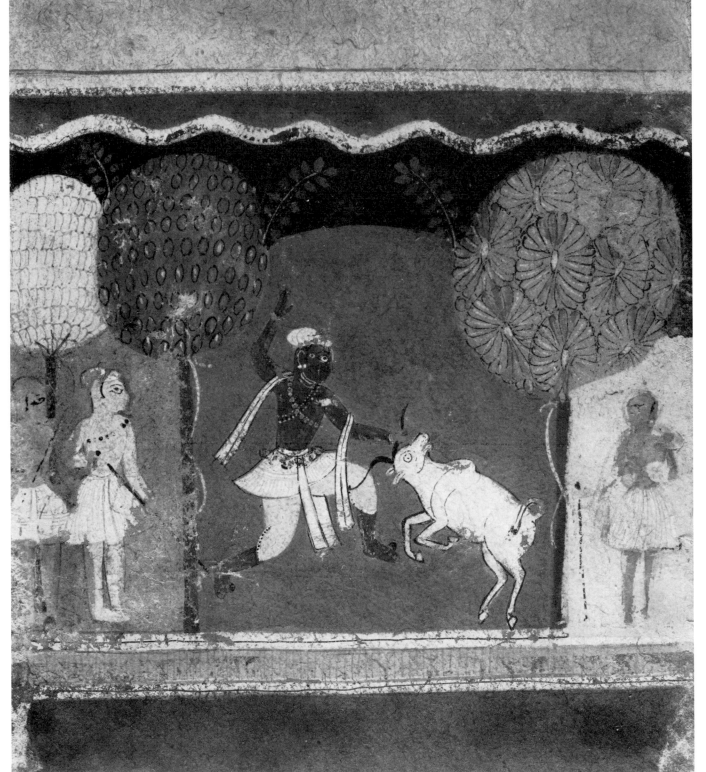

Madhu-Mādhavī Rāginī[1]

from a *Rāgamālā* series

Central India, Malwa, ca. 1660
16.5 x 16 cm painting; 21.5 x 17.1 cm
page
Gift of Alexander H. Bullock,
1954.24
Ex. coll.: A. K. Coomaraswamy

A nighttime storm arises as a lady, accompanied by her attendant, makes her way to the house of her lover. Rain pours down, lightning flashes, and a peacock screams, startling the lady. She reaches up to stop the peacock's cry.

A *Rāgamālā* ("garland of musical modes") painting conveys through visual forms certain emotions that arise from a mood or situation. Since these emotions are also expressed in a melody of the same name, the painting is often thought to be an interpretation of a musical mode. More frequently, however, the iconography of the painting is linked to an accompanying text. Madhu Mādhavī ("honeyed sweetness") is a feminine mode to Bhairava *Rāga* and is illustrated here as an *abhisārikā nāyikā*, a woman who goes out through danger to meet her lover.[2] Like all such ladies, she is accompanied by a *sakhī* ("friend"), who serves, if need be, as a go-between. On the back of the painting is a poem in Hindi, which provides a narrative.

"Thus the description of Madhu-mādhavī:

Madhu-mādhavī, a woman treasury of beauty,
 dark complexioned, all her body dusky,
With her many kinds of jewels, very lovely, pale of mien
 by reason of her many desires.
With blue-black garment, going seeking, torn asunder
 by her longing for her darling,
Her heart attached to union with her lover.—
 Heavy rain is pouring down and black night fallen;
The flickering lightning flashes out (betraying her) and
 then for shame she staggers,
And in that moment a peacock rises screaming,
 and with a startled gesture the impassioned woman
 lifts her arms.

"*Doharā:*

To Bhairava her noble lord,[3] she goes afoot on *abhisāra*,
Seeing but the bird, and not his palace, her glances show
 her heart's distraction."[4]

The peacock, a common iconographic element in Indian painting, is a sign that lovemaking is imminent. The lovers' passion is also reflected in the storm, which threatens the heroine's life and reputation. For further discussion on this iconography, see *The Storm* (p. 74).

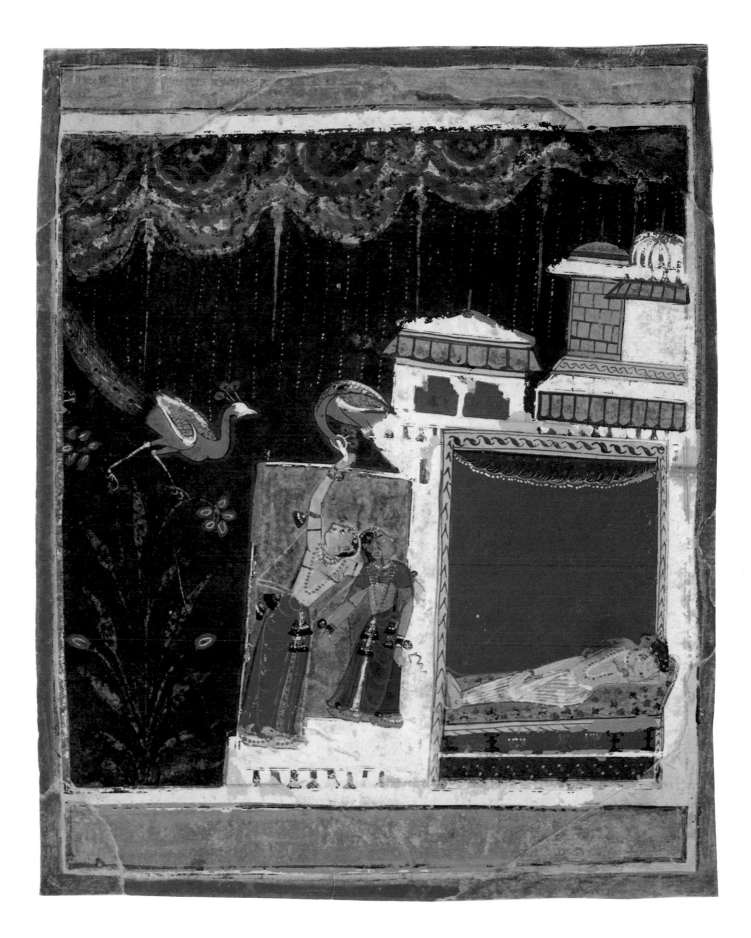

This picture owes its charm to the brilliance of its colors and the liveliness of its figures.[5] Amidst the conventional idioms of early Malwa painting—the flatness of the scarlet chamber, the sage green vestibule and black night, and the pictorial compartmentalization—the artist has placed some delightful touches: the peacock dancing in mid-air (detail); the lady, already anxious with anticipation, shamefully caught by the peacock's scream; the lover facing away, oblivious to it all; and the oversized, almost ornamental flowers rising in the night.[6]

[1]This painting is part of the 1660 *Rāgamālā* series in the Museum of Fine Arts, Boston.

[2]Malwa paintings of this *rāginī* typically show a lady rushing out of the rain into a palace and a gentleman lying on a bed. Occasionally there are peacocks on the roof, perched in a tree, or flying in the air. *Ebeling*, p. 60; cf. C22, C23; *Archer and Singh*, pl. 33.

[3]A form of the god Shiva.

[4]A. Coomaraswamy, "Hindī Rāgmālā Texts," *Journal of the American Oriental Society* 43 (1923): 399–400.

[5]Although this painting has been heavily damaged—major portions of all four corners have been torn away, replaced, and repainted—the bright colors of the original are undiminished.

[6]Cf. *Pal 1978*, no. 10.

Literature:
Coomaraswamy, "Hindī Rāgmālā Texts," pp. 396–409.
Objects.
WAM Annual Report 59 (1955): ix.

Detail of *Madhu-Mādhavī Rāginī*

Dīpaka Rāga

from a *Rāgamālā* series

Central India, Malwa, ca. 1660[1]
19.2 x 13.8 cm painting; 20.8 x 15.4 cm page
Museum purchase, through gift of Alexander H. Bullock, from Kevorkian Foundation, N.Y., 1953.41
Ex coll.: Heeramaneck Galleries, N.Y.

Under a canopy of brightly patterned hangings, a prince draws his lady towards him, as she points to a flaming lamp on the wall. The two lovers sit on a footed couch set deep in the interior of the palace. Outside their chamber, a female friend fills the night with music on her vīnā.

The inscription reads:

"In the middle of the night, the happy lady lover extinguishes the lamp but becomes embarrassed because of the lights from her head ornaments; where in the world is such a lamp?"[2]

The title of this painting is in a larger, hastier (and perhaps later) hand than the rest of the inscription, but it is undoubtedly correct given the iconography of love by lamplight.[3] As its name indicates, Dīpaka ("light," "lamp") *Rāga* occurs after the evening lamps are lit, when the dark of night has descended.[4] The hero is a wealthy prince surrounded by fine pleasures and amorous women. His current lady, however, is somewhat bashful about the prince's aggressive attentions.

The two-dimensional architecture and the flat backgrounds of color place this piece at the height of Malwa painting. The pictorial compartmentalization, typical of this school, is enhanced by the beautiful lines of the building, whose ornamental moldings are elaborately echoed in the floral scroll at the bottom—itself a convention among Malwa painters.[5] The traditional palette of basic, vivid colors is interrupted here only by the deep maroon of the lady's skirt, around which the yellow chamber, slate blue vestibule, black sky, and red couch and windows are especially brilliant. The black and gold tassels on the women and bolster and the horizontally striped skirt of the musician are, again, hallmarks of Central Indian painting.

[1] *Welch and Beach,* pls. 16 a-c.
[2] I am indebted once again to Vishakha Desai of the Museum of Fine Arts, Boston, for her translation, which was made with the aid of the original translation by O. C. Gangoly, *Rāgas and Rāginīs* (1935; reprint ed., Bombay: Nalanda Pub., 1948).
[3] For a painting with almost identical iconography, see *Ebeling,* C24.
[4] N.B., however, the remarks in *Pal 1967*, no. 23.
[5] V. P. Dwivedi, "Two Kedara Ragini Paintings," *Bulletin, Cleveland Museum of Art 55* (1968): 25, figs. 2, 4, 5; *Ebeling,* p. 40. See also *Barrett and Gray,* p. 153; *Pal 1967,* nos. 6, 55.

Literature:
Heeramaneck, no. 58 (as *Varari Ragini*).
WAM News Bulletin and Calendar 18, no. 8 (May 1953): 35 (illus.) (as *Varari Ragini. Love Scene in a Palace*).
WAM 1953, pp. 11-12 (as *Varari Ragini...*).
WAM Annual Report 57 (1953): xii (as *Varari Ragini...*).
Objects (as *Varari Ragini...*).

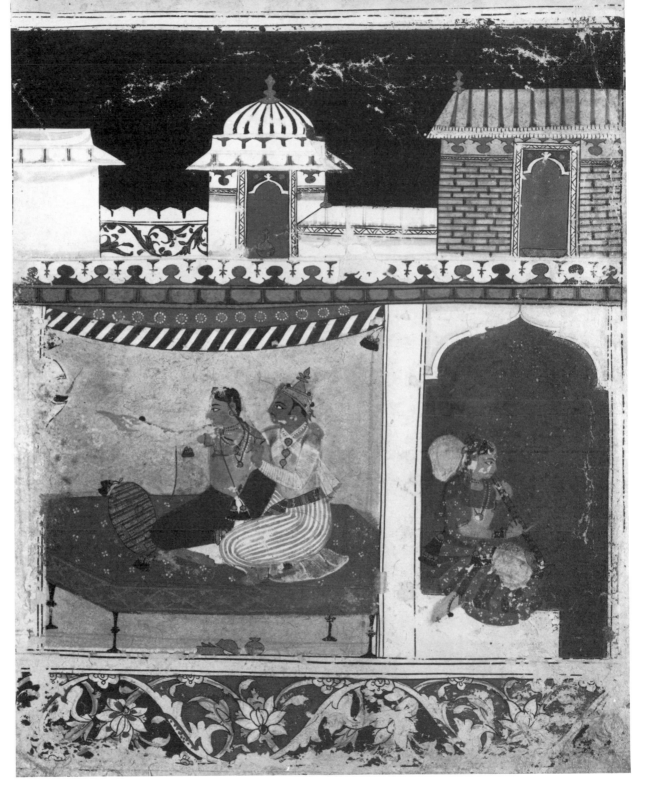

Vilāvala Rāginī

from the same *Rāgamālā* series as *Gaura-Mallāra Rāginī*

Central India, ca. 1750
19.5 x 11.2 cm painting; 25.2 x 16.6
cm page
Gift of Alexander H. Bullock, 1956.2
Ex coll.: Kevorkian Foundation, N.Y.

Seated on a raised platform, a lady in gold adjusts her earring in a mirror held by one of her attendants. Another attendant waves a fly-whisk overhead, while still others fill the intimate chambers with their chatter.

Before meeting her beloved at the trysting place, Vilāvala, with her traditional dark complexion, adorns herself with jewels. Although the original design has been cut by the floral border—added sometime in the late nineteenth or early twentieth century—enough of the inscription remains to indicate that, as in the following painting, the verse ends with "Rāma, Rāma, Rāma." This is a peculiarity of this series, however, for neither Vilāvala nor Gaura-Mallāra are traditionally associated with the hero-god Rāma.

The composition of both pictures—the large architectural setting of this and the centrally located figure of the next—are typical of paintings from central India. Equally typical are the treatment of the foliage and facial features. Pal, however, has attributed a painting from the same manuscript—now in the Museum of Fine Arts, Boston—to Bikaner, eighteenth century,[1] and Ebeling has attributed a painting similar to *Gaura-Mallāra Rāginī* (see following entry) to Jaipur, eighteenth century.[2] The faces in these two paintings, though, are unlike typical Bikaner faces, and the palettes are not bright enough to be from Jaipur.

[1] *Pal 1967*, no. 22, pl. 10.
[2] *Ebeling*, pl. 249.

Literature:
H. Kevorkian, *Persian and Egyptian Art, Oriental Rugs*, exh. cat. (New York: American Art Association, 1928), p. 144.
WAM Annual Report 60 (1956): 14 (as *The Toilet of the Princess*).

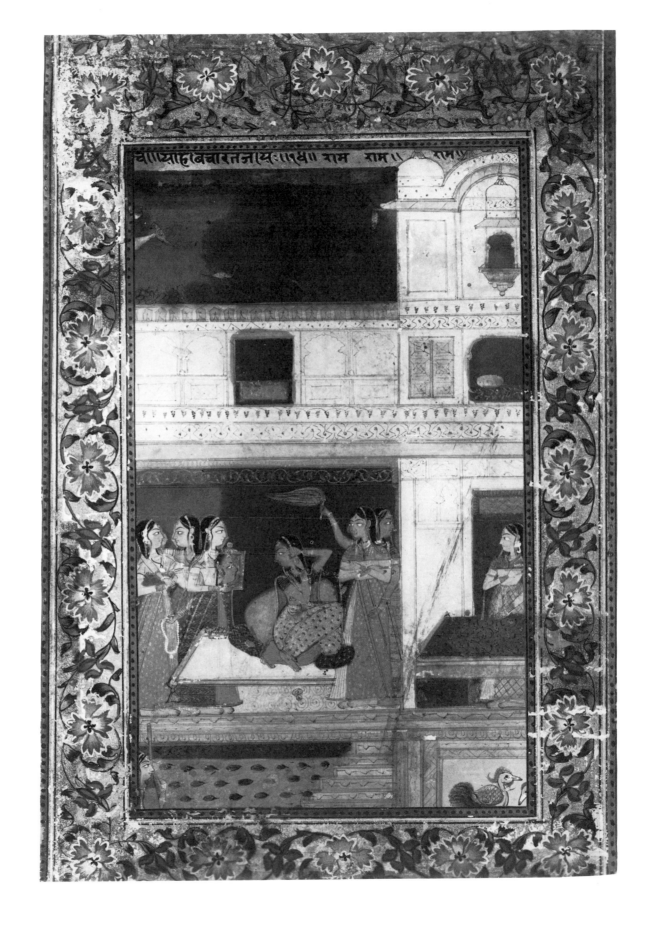

Gaura-Mallāra Rāginī

from the same *Rāgamālā* series as *Vilāvala Rāginī*

Central India, ca 1750[1]
19.6 x 11.3 cm painting; 25.2 x 16.9 cm page
Gift of Alexander H. Bullock, 1957.8
Ex coll.: Heeramaneck Galleries, N.Y.

Seated on a throne of red and white lotus petals and surrounded by animals, a lady in pink, orange, and gold holds a vīnā high as she sings and admires a flower from her beautiful forest garden.

Gaura-Mallāra is depicted here as an *utka nāyikā*, a woman who expects and yearns for her lover, and like the traditional *rāginī*, she sings a song of her beloved. Gaura-Mallāra is thought to be the personification of all that is beautiful and charming, and is so because her love has filled her with a radiance so dazzling she cannot help but lure all creatures to her.

The dark floral border on this painting, as on *Vilāvala Rāginī* (see preceding entry), was added much later. As a result, when compared to similar examples of the same *rāginī*,[2] this work appears to have lost a number of animals—pairs of which belong to the traditional iconography of Gaura-Mallāra—and the major portion of two companions to the right, as well as most of the inscription ending in "Rāma, Rāma, Rāma."

Despite the water stain covering the left half of the painting, the colors are still clear, though not vibrant. The treatment of plants and landscape is typical of Central Indian painting of this period; while the foliage of the stylized and inanimate trees, in the shape of long-handled fans,[3] is traceable to the earlier Malwa convention of reducing trees to schematic ovals. Equally conventional is the lady's soft face, the tilt of her head, and the high, rounded hill behind. The regular placement of floral bunches on the hillside, however, is part of Gaura-Mallāra's standard iconography, which calls for the tasteful arrangement of flowers around her.

[1] *Binney: Rajput*, nos. 51-52. Cf., however, *Ebeling*, pl. 249, attributed to Jaipur, 18th century, which is very similar to our painting both in style and iconography.
[2] *Binney: Rajput*, no. 52; and *Ebeling*, pl. 249.
[3] *Binney: Rajput*, p. 67.

Literature:
Heeramaneck Galleries, *Asiatic Art, VII Century B.C.—XVIII Century A.D., Collection Formed by Heeramaneck Galleries, New York*, exh. cat. (New York: American Art Association, 1929), pp. 58-59, no. 201 (illus.).
WAM Annual Report 61 (1957): 13 (as *A Ragini Seated on a Lotus Throne Singing While a Peacock Dances*).

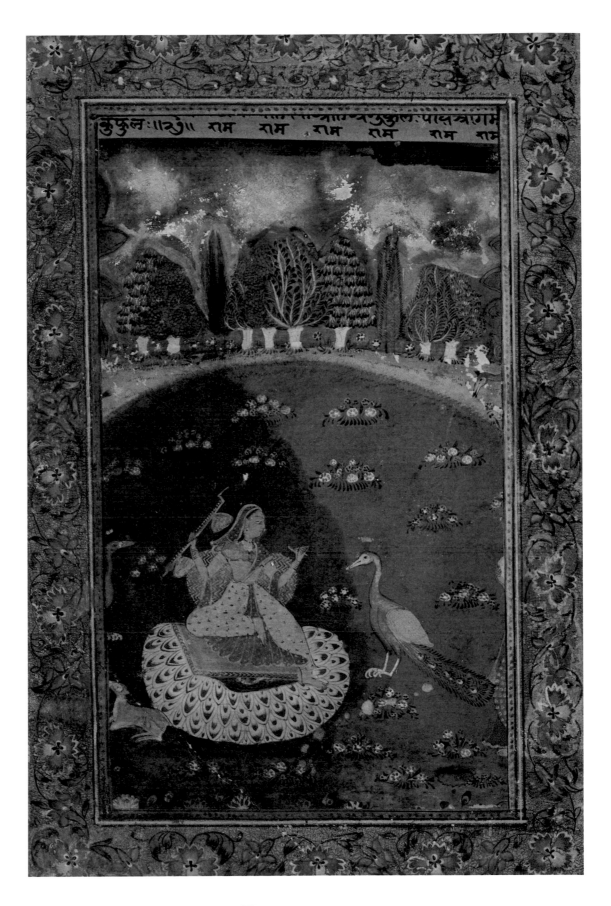

Meghamallāra Rāga
from a *Rāgamālā* series

Rajasthan, Sirohi, ca. 1690
22.2 x 14.9 cm painting; 25.1 x 16.2
cm page
Museum purchase, through the gift of
Alexander H. Bullock, from the
Kevorkian Foundation, N.Y., 1953.42
Ex coll.: Heeramaneck Galleries, N.Y.

Against a dark red, rain-splashed
background, a blue prince and his
lover dance to music created by two
female companions with drum and
clappers. Overhead two peacocks
and a turbulently colored monsoon
sky signal the season of love, and
underneath decorative niches are
filled with flowers.

Meghamallāra *Rāga* takes place during the rainy season, when clouds (*megha*) and brilliantly colored skies send lovers dancing in the rain. It is the music of the lovers' companions that arouses the stormy skies, and both mirror the lovers' passionate feelings for one another.

"Megh-mallar is a good, wise king. He dances well and enjoys the pleasures of life with gay abandon. Of a slightly dusky complexion with bright shining eyes, king Megh-mallar is dressed handsomely, wearing a tiger skin, and adorned with various kinds of bright ornaments. He is in the company of beautiful maidens bedecked with jewels. The king dances with them to the resounding beat of drums and of clapping. The dancing and music bring forth clouds of various colors in the sky. The moving clouds thicken to the accompaniment of thunder and lightning, which brings the rain."[1]

Although the name Mallāra is also used for Shiva and an earthly prince, here it describes Krishna, who is typically portrayed with deep blue skin, a sheer, yellow *jāma'*, and an amorous setting. The lady, then, is Rādhā. The cranes overhead, in flight now that the monsoon has begun, are symbolic of love to be fulfilled.

Towards the end of the seventeenth century, Sirohi produced a small number of striking and beautiful *Rāgamālās*. Stylistically, paintings from these sets are related to those from nearby Mewar,[2] sharing with them, for example, the flat red background, the yellow outline of the floral niches, and certain facial features. The figures in Sirohi paintings, however, are more carefully and sharply drawn, the color more saturated (reds deeper, yellows more intense), and the composition simpler and bolder—with its elements drawn so large they crowd out most of the space in the picture and often overflow into the margins. Furthermore, Sirohi faces—especially in paintings from the late Sirohi tradition, like this one—have stronger profiles, with large staring eyes, long pointed noses, and prominent lips.[3]

The floral niches at the bottom of this work are a common feature of Rajput painting in this region,[4] and they are almost always present in Sirohi painting of the period.[5] They are reminiscent, perhaps, of the formal, symmetrical Mughal borders popular during Shāh Jahān's reign,[6] but preserve, all the same, the juxtaposed areas of solid color so characteristic of Sirohi/Mewari painting. The turbulently colored sky is like those found in paintings from the nearby state of Bundi. One particular pleasure of this work is its unified design, with the flying cranes overhead (detail) completing the circle begun by the swing of the lovers' skirts below.

[1] W. Kaufmann, *The Ragas of North India* (Bloomington: Indiana University Press, 1968), p. 396.
[2] *Ebeling*, p. 42.
[3] Cf. *Pal 1978*, nos. 18, 20-21.
[4] S. E. Lee, *Rajput Painting* (New York: [Asia Society, 1960]), p. 55; *Chandra*, cat. no. 133; *Pal 1978*, nos. 19, 34.
[5] See *Pal 1978*, no. 18; and *Ebeling*, C19, C31-32, C41, C45.
[6] See *Welch 1978*, pl. 35; H. Goetz, "The First Golden Age of Udaipur: Rajput Art in Mewār during the Period of Mughal Supremacy," *Ars Orientalis* 2 (1957):432, fig. 21.

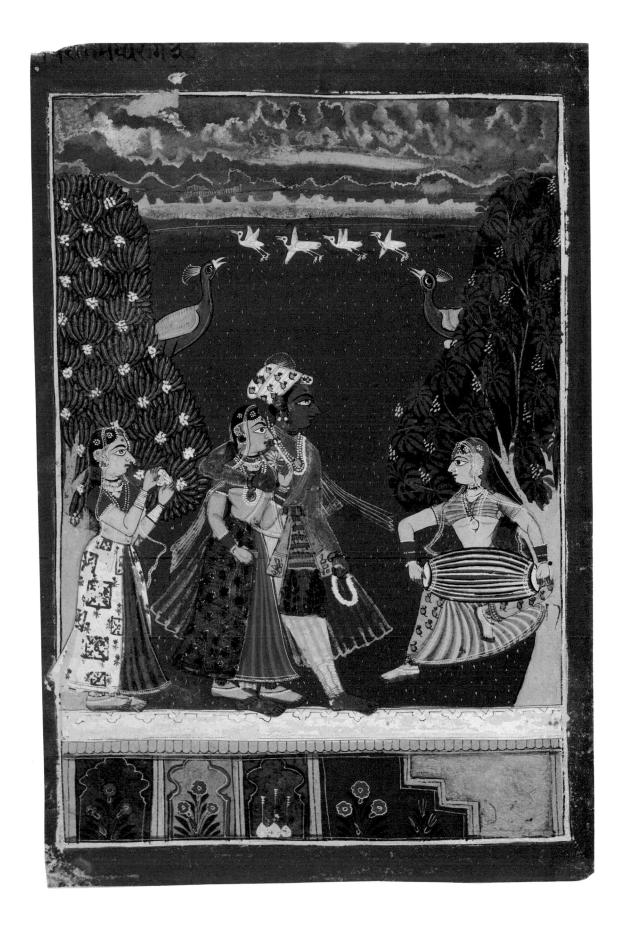

Literature:

A. C. Eastman, *Catalog of the Heeramaneck Collection of Early Indian Sculptures, Paintings, Bronzes and Textiles* (New York: Heeramaneck Galleries, 1934), no. 58 (as *Viragamadhya Raga*).
Objects (as *Lovers with Two Attendants*).
WAM 1953, pp. 11-12 (illus.) (as *Lovers...*).
WAM Annual Report 57 (1953): xii (as *Lovers...*).
Archer and Singh, pl. 41 (as *Lovers with Girl Musicians*).
A Handbook to the Worcester Art Museum (Worcester: Worcester Art Museum, 1973), p. 204 (illus.).

Detail of *Meghamallāra Rāga*

The Month of Mārgashīrsha: Winter Season
from a *Bāramāsā* series[1]

Rajasthan, Amber, ca. 1700[2]
26.9 x 17.4 cm painting; 30.4 x 21.8 cm page
Gift of Alexander H. Bullock, 1954.151

As her female attendants straighten the couch and prepare the room, a lady greets a nobleman come to call on the terrace outside. Birds fly overhead, and below cranes parade through a well-tended garden of trees and flowers, crossed by a geometric lily pond.

The *Bāramāsā* is a series of poems portraying the twelve months through the longings of a woman for her lover.[3] The month of Mārgashīrsha, November/December, is described in a verse at the top of our painting.

"In this month, everyone tries to acquire an element of God;
By giving up selfishness and giving to others for their benefit;
In this season, Keshava says,
Rivers flow well, flowers are full of fragrance,
[Male] swans sing their tunes in response to the female ones;
At the time in Magsar, when the husband is away, the lady's
 heart is on the road [awaiting the arrival of her lover]."[4]

Despite its close Mughal alliance, painting at Amber was well within the tradition of contemporary Rajput schools. It was especially noted for its neat geometric compositions, its crisp, clear colors (the red and gold dresses, green garden, and pink moldings and bed), and its frequent use of white. While the compartmentalization of the picture is typical of many paintings from Rajasthan, the man's fixed composure, the women's flat, receding, veiled hair, and the staccato rhythm of the pointed trees are peculiar to Amber. Mughal influence is evident, however, in the delicate detailing and careful drawing of the figures.

[1]Other leaves from this series can be found in the Museum of Fine Arts, Boston. See *Coomaraswamy 1926*, pp. 191–92, pls. 104–5.
[2]Based on *Ebeling, Rāgamālās* nos. 44–46, 48–49.
[3]The usual text of a *Bāramāsā* series is the *Kavipriyā* of Keshavadāsa, chapter 10.
[4]Again, I am indebted to Vishakha Desai for her translation.

Exhibitions:
WAM 1926
Chicago 1926

Literature:
WAM Annual Report 59 (1955): ix (as *A Prince or Nobleman Calling on a Lady*).

॥मोसनमेहरिश्रंसकहतथ्यासदसबकीई स्वारथपरमोरचनिदेतनारयमहिदोई केम
बुसरितासरवकूलफूलेसुगंध्युर कुंजितकलकलहंसकलितकलहंसनकेसुर दिनयर
मनरमसीतलगरमकरमकरमकरिपायेरति कहिकेसव्दाछमतिमारगसिरमारगनधि
ता॥

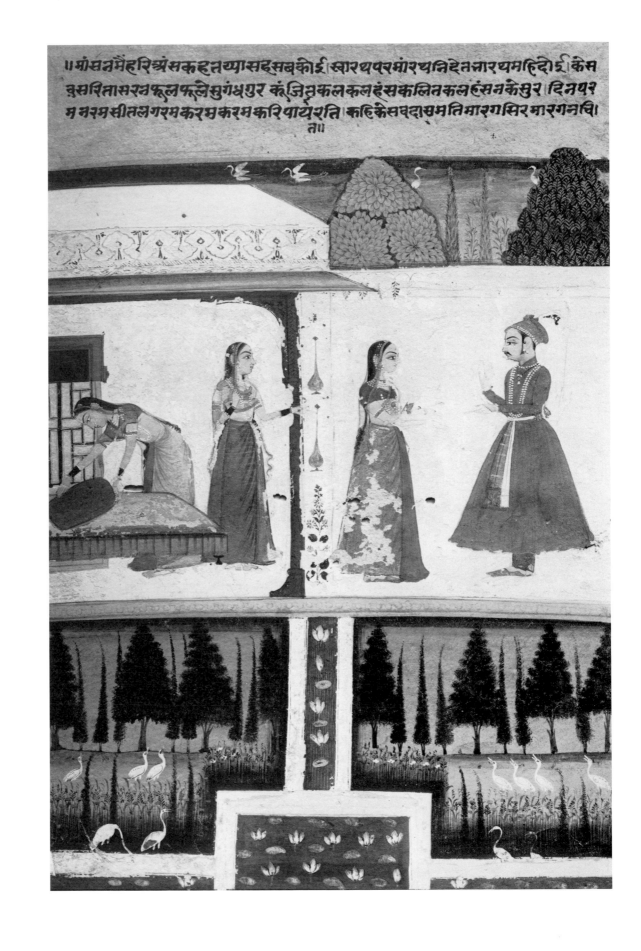

Rādhā Welcoming Krishna

Rajasthani style, Raghogarh (?),
ca. 1750
21.1 x 15.8 cm painting; 29.8 x 22.4
cm page
Gift of Alexander H. Bullock,
1952.12

Approaching the chamber, a light
gray Krishna dressed in a long, sheer,
yellow jāma' *over orange and black*
striped paijāmas, *is greeted by Rādhā*
on a low white stool. Her black skirt
is beautifullly decorated, as is the yel-
low and purple rug and the gray and
gold ornamentation of the building
above.

This painting reflects the on-going Rajasthani interest in Rādhā and Krishna, but does not treat the two lovers with the usual abandon. Instead, Rādhā is a lady of the house, settled in her domesticity, and Krishna a nobleman come to call. The only faintly erotic details are Rādhā's open arms and Krishna's posture of submission—but the mood is more one of reception than of passion, and the scene could easily be a son returning home to his mother rather than a promiscuous, but penitent, lover returning to his ever-faithful and forgiving lady.

Raghogarh is a state (*thikana*) in central India, near Malwa and Bundi. To date little is known of its artistic tradition, but it is clear that it belongs to the Rajasthani school and that it borrowed a number of elements from its neighbors. From Malwa came a type of large, bold architecture; and from Bundi, an interior composition and a lilting face with receding forehead, pointed skull, and narrow eye. The bold ornamentation on the building, with its relief shown in shadows of gray, is typical of Raghogarh, as are the finely drawn lines and the sensitive rendering of the faces.[1]

[1] Cf. *Pal 1978*, no. 41.

Literature:
WAM Annual Report 57 (1953): xii.
WAM 1953, pp. 11–12 (illus.).
Objects.

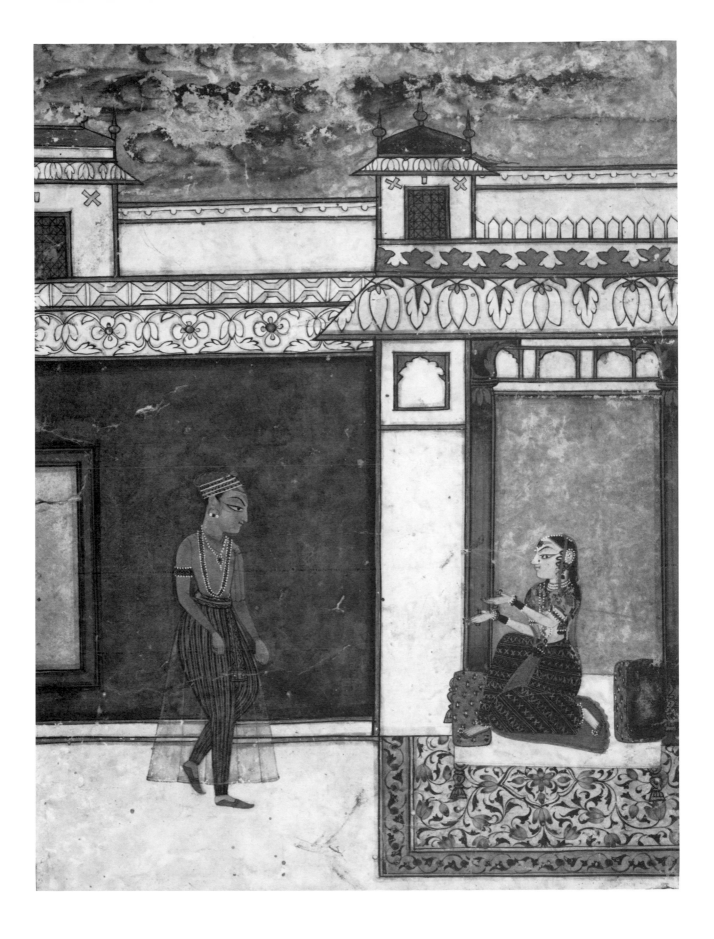

Krishna Disguised as a Musician

Rajasthan, Bundi, third quarter 18th century
24.6 x 15.5 cm painting; 33 x 24 cm page
Gift of Alexander H. Bullock, 1958.43
Ex coll.: Kevorkian Foundation, N.Y.

Against a background of luxuriant foliage, Krishna comes forward disguised as a female musician to play his vīnā for Rādhā. She sits shyly on the edge of a terrace, pulling a gold veil over her face. In the lotus pond below, a boat, presumably Krishna's, awaits the loving pair.

Rādhā's and Krishna's relationship is an allegory of man's path to God. The language of the spiritual quest—the first meeting, dalliances, separations, frustrations, and final consummation—is the language of profane love.

While the passion of Rādhā and Krishna is famous, the extent of Krishna's playfulness is less often told. He teases the *gopīs* ("cowherdesses"), to be sure, but his humor is also directed at his favorite, Rādhā. In the poems of the Bengali Chandi Das, Krishna periodically goes into disguise in order to woo back his injured lady. In one instance, he dresses himself as a *gopī* and pretends to sell flowers; and in another, as a doctor in order to treat the heart-sick Rādhā. Here again, Krishna is incognito, this time as a female musician, who by "her" beautiful melodies hopes to soften the shy, but stubborn, Rādhā and turn her thoughts towards forgiving the repentant Krishna. The pairing of peacocks and ducks foreshadows her capitulation.

According to Archer, the ivory face with red-shaded cheeks seen here is a Mughal influence that appears in Bundi painting after 1760. Many of these paintings are based on the Krishna story and portray the hero as a sluggish, complacent man, unlike the sprightly god of earlier Bundi works.[1] The formulaic rendering of the figures and the poorer technique indicate, moreover, that there is little innovation in Bundi at this time.[2] Nevertheless, the brilliant colors (reds, oranges, yellows, greens) and the wild, frenzied foliage with its suggestive banana leaves are typical of the Bundi tradition as a whole and make the overall effect of the painting immensely powerful.

[1] W. G. Archer, *Indian Painting in Bundi and Kotah* (London: Her Majesty's Stationery Office, 1959), p. 6.
[2] M. C. Beach, *Rajput Painting at Bundi and Kota* (Ascona, Switzerland: Artibus Asiae, 1974), p. 20.

Exhibition:
Smith 1980

Literature:
H. Kevorkian, *Persian and Egyptian Art, Oriental Rugs, New York*, exh. cat. (New York: American Art Association, 1928), p. 148–49 (illus.).
WAM News Bulletin and Calendar 24, no. 5 (February 1959): 20 (illus.).
WAM Annual Report 63 (1959): ix (as *Krishna Disguised as a Musician Playing the Vina Approaches Radha*).

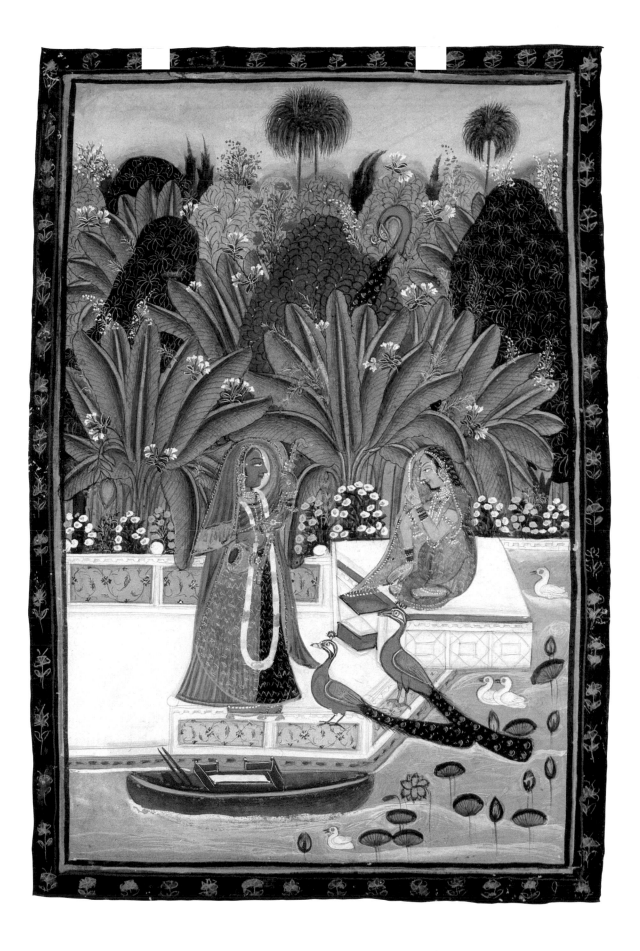

The Chess Game

Rajasthan, ca. 1840
19.5 x 14.2 cm painting; 19.5 x 14.2 cm page
Bequest of Mrs. Frank E. Heywood, 1937.79

Smoking a long-stemmed huqqa, *a lady plays chess with her attendant, as thunderclouds float across the sky. A eunuch in blue stands guard holding a fan of peacock feathers.*

Chess and other board games were popular pastimes among ladies of the palace. Here red and green pieces won by each player are seen beneath the footed board. Although formerly entitled *A Prince with a Lady and Attendant,* this painting actually depicts two women playing chess. The image does suggest a typical love scene, but the long hair, hennaed feet, and jewelry of the central figure clearly indicate it is a woman.

The composition—particularly the seated figures facing each other, the simple square building, and the plain landscape behind—is typical of nineteenth-century painting in places like Jaipur.[1] And as in other Rajasthani paintings of this time, Mughal influence is evident in the careful finish and attention to detail. Note, for instance, the dark foliage illuminated by the impending storm; the repetition of gold patterning in the female attendant's dress, the large bolster, the hats, and the building behind; and the softly modeled roundness of the faces. The rendering of the "still life" fruit and ceramics on the table is in the Mughal tradition, as is the style of clothing: the hats, in particular, are copied from the very latest fashions of dancers at the Mughal court. The formulaic landscape,[2] as well as the gaudy colors and emphasis on realistic rendering of detail are typical traits of the Indian tradition increasingly in contact with the European world.

[1]Cf. *Ebeling, Rāgamālās* nos. 125, 267, 268ff.
[2]Cf., for example, S. C. Welch, *Room for Wonder: Indian Painting during the British Period 1760–1880* (New York: American Federation of Arts, 1978), no. 2; and *Chandra,* no. 80.

Exhibitions:
WAM 1926
Chicago 1926

Literature:
WAM Annual Report 42 (1938): 13 (as *A Prince with a Lady and Attendant*).

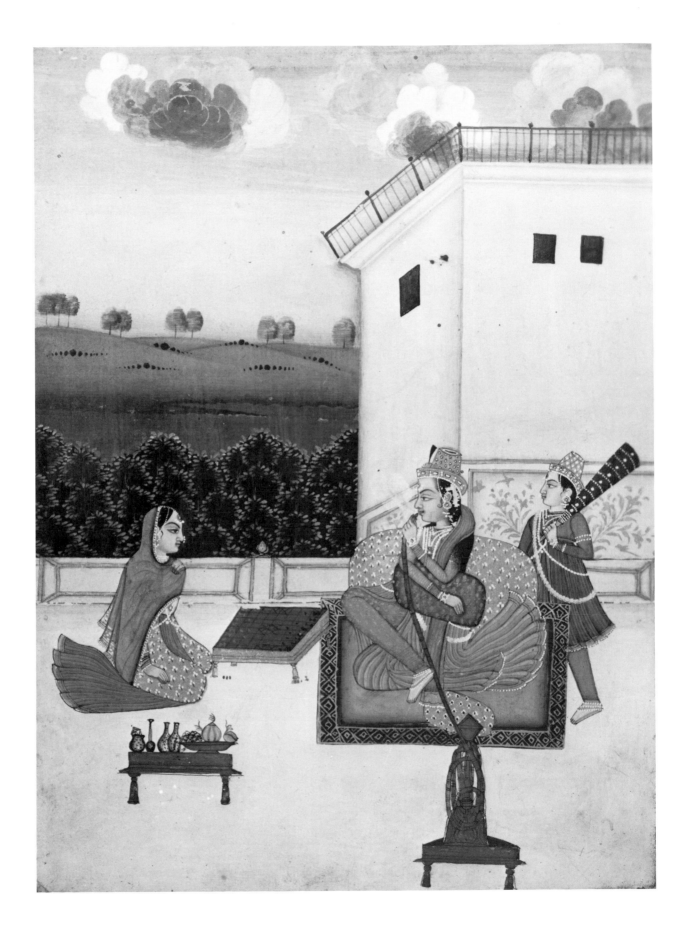

Miān Kisann[1]

Punjab Hills, Mankot, first quarter 18th century
16.7 x 11.5 cm painting; 21 x 15.7 cm page
Gift of Alexander H. Bullock, 1953.81

Miān Kisann wears a bright orange red jāma', *a white* kamarband *with gold ends, and a purple turban and slippers. In his ears are the commonly worn rings of two pearls and a ruby, and in his hands a pet bird and dagger.*

In no other Pahari state were portraits painted with such zeal and in such number as in Mankot. Almost everyone of any consequence was portrayed, and Miān Kisann, a noble of lesser rank, was no exception. Nobles of Pahari families often had the title "Miān" and were required to attend the Mughal court.[2] Although we don't know Miān Kisann's precise position or duties, it is clear he enjoyed the usual pastimes: keeping birds and learning the arts of war.

Our painting is from a late phase of Mankot portraiture that owes much—especially fine modeling and meticulous line and detail—to the earlier tradition of Mughal portraiture. It does, however, have strong Rajput features, particularly the use of flat planes, the deliberate lack of perspective, and the broad expanses of color. From the Basohli style, Mankot painters borrowed the large, staring almond eye and the use of strong contrasting colors, but they developed their own idioms of the long, receding profile, pronounced nose, carefully modeled face (particularly around the eye), and a more balanced and refined use of color. Though a late example, this portrait of Miān Kisann is well executed and wonderfully colored; and through his small feet, tight mouth, double chin, and expressive hands, it reveals a decided personality.

[1]Based on the inscription on the back of the painting.
[2]*Coomaraswamy 1926*, p. 8; B. N. Goswamy, "The Problem of the Artist 'Nainsukh of Jasrota'," *Artibus Asiae* 28 (1966): 210.

Literature:
Objects.
WAM 1953, pp. 11–12 (illus.).
WAM Annual Report 58 (1954): ix.

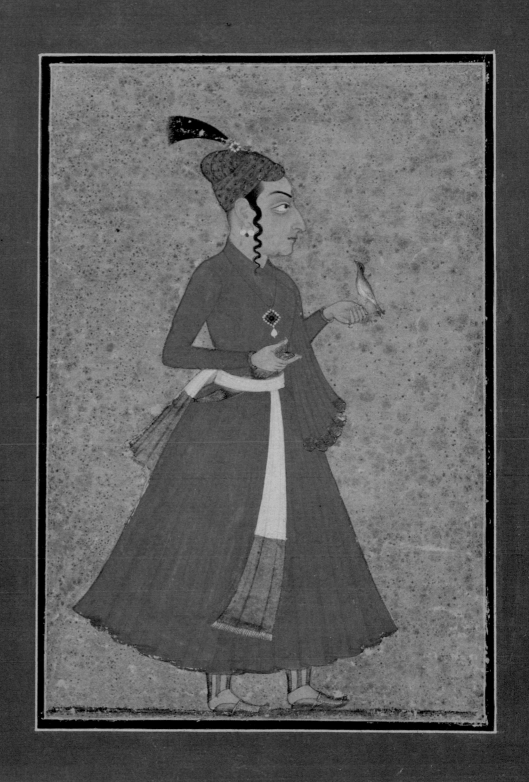

Prince with Huqqa

Punjab Hills, Guler, third quarter 18th century
19.8 x 28.2 cm painting; 24.2 x 32.8 cm page
Museum purchase, through Jerome A. Wheelock Fund, from Heeramaneck Galleries, N.Y., 1935.28

In a pavilion set in a flower garden, a prince sits smoking his long-stemmed huqqa. *He watches as an attendant helps her lady apply an ornamental spot* (tilaka) *to her forehead.*

This painting is a portrait of a Guler prince or nobleman whose identity remains unknown.[1] The isolation of the subject in his pavilion, his quiet pose, and his well-defined features clearly indicate the artist's intention of carefully rendering a likeness of an important figure for posterity.

Our eyes are drawn immediately to the two interior scenes, where the strongest colors of the painting lie: yellow and purple in the prince's *jāma'* and bolsters, and orange and blue in the dress and setting of the women. Yet the garden is also an important part of the painting, with its typically Guler beds of poppies,[2] flowering trees, and tall cypresses. Also of Guler origin are the compositional use of the diagonal, rectilinear architecture, muted colors, and wavy hills.

Although intended as a portrait, the painting has all the markings of a standard tryst scene: while the lady makes her preparations, the lover awaits their meeting—perhaps in the garden, but more likely inside the pavilion, given the overall reserve of the painting. The exquisite rendering of the female form is noteworthy (detail), for Pahari artists increasingly conveyed romantic love through idealized female beauty.[3] Unlike *Nāyikā with Deer* (p. 72) and *The Storm* (p. 74), which represent the passions of only the woman, this painting allows the viewer to experience preparations for the tryst through the eyes of both lovers.

[1] According to museum files, a number of scholars who viewed this painting believed it to be a portrait of Rājā Balwant Singh of Jammu (1724–1763), a prince famous for his predilection for preserving the minute details of his daily life in miniature form. Cf., for example, *Archer 1952*, figs. 35–39; *Archer 1973*, 2: Jammu pls. 30ff.; W. G. Archer, *Visions of Courtly India: The Archer Collection of Pahari Miniatures* (London: Sotheby Parke Bernet, 1976), fig. 31; *Barrett and Gray*, p. 179; K. J. Khandalavala, "Balvant Singh of Jammu—A Patron of Pahārī Painting," *Bulletin, Prince of Wales Museum, Bombay* 2 (1951–52): 71–81, pls. 8–13; *Welch and Beach*, p.49, pl. 36; S. C. Welch and M. Zebrowski, *A Flower from Every Meadow* (New York: Asia Society, 1973), p. 81.

B. N. Goswamy, however, on the basis of his extensive study of Balwant Singh and his personal artist, Nainsukh, remarked during a July 1972 visit to the museum that this prince did not resemble known portraits of Balwant Singh and therefore could not be identified with him. See B. N. Goswamy, "The Problem of the Artist 'Nainsukh of Jasrota,'" *Artibus Asiae* 28 (1966): 205–10.

[2] See *Archer 1973*, 2: Guler figs. 42, 44, 45(i).

[3] *Archer and Singh*, pl. 87.

Exhibitions:
The Asia Society, New York, 29 November 1960–22 January 1961
The Garden in Islamic Art, Mount Holyoke College, South Hadley, Mass.,
26 March–27 April 1980

Literature:
A. C. Eastman, *Catalog of the Heeramaneck Collection of Early Indian Sculptures,
Paintings, Bronzes and Textiles* (New York: Heeramaneck Galleries, 1934), p. 20,
no. 63.
WAM Annual 1 (1935–36): 38, 47-48 (illus.).
WAM Annual Report 40 (1936): 12 (as *Garden Pavilion*).
Art through Fifty Centuries from the Collections of the Worcester Art Museum
(Worcester: Worcester Art Museum, 1948), p. 31, fig. 42.
Objects.
Archer and Singh, pl. 87 (as *The Tryst*).

Detail of *Prince with Huqqa*

Nāyikā with Deer

*Punjab Hills, Guler, third quarter
18th century
16.5 x 11.3 cm painting; 16.5 x 11.3
cm page
Museum purchase from Ananda K.
Coomaraswamy, 1926.4*

*Pulling on her veil as it slips from her
shoulders, a young woman gazes pro-
vocatively at a deer. In the back-
ground, two companions talk as
thunderclouds fill the sky.*

This painting recalls the traditional Indian theme of "eye and gaze." The great affec-
tion and powerful intimacy between the *nāyikā* ("heroine") and her deer is revealed
by her intense focus on its face—not, incidentally, unlike that of a lover. This flirting
gaze is mirrored in the two companions behind, as is the young woman's serenely
graceful, but teasing, posture.

Coomaraswamy interprets the painting from the point of view of the deer, rather
than, as expected, from that of the woman:

"The pet deer, though it has escaped the dangers of the chase and the pitfall, is yet
attached to the beautiful maiden, and is likened to the soul entangled in *māyā*. This
thought recalls the Vedānta use of the terms *mriga-jala* and *mriga-trishnā*, 'deer-
water' and 'deer-thirst,' that is to say mirage, or illusion. In the Psalm of the Bud-
dhist Ratthapāla, too, the individual who seeks not the pleasures of this world but the
Abyss (*nibbāna*), is likened to the deer for whom the trapper lays his net in vain."[1]

For many years, paintings such as this have been assigned to Kangra. This attribu-
tion, which is based upon earlier attributions of Coomaraswamy,[2] is problematic; for
the only paintings known to have been produced in Kangra are a group of portraits
bearing little resemblance in design or iconography to this or other works classified
with them.[3] The aesthetics of this painting, with its delicate lines, fresh lyricism, and
soft restraint, is closer to that of Guler. The subtle tonality (pink, sage green, orange,
and blue gray) is also typical of Guler painting and is balanced by unfinished areas of
white, which reveal the finely drawn lines of the buildings. In the central woman,
moreover, is embodied the new notion of femininity prominent among Guler artists:
tall, slender bearing; delicate, sweet face; and tranquil demeanor, despite her intense
feelings. The oval border, usually vertical and giving the appearance of an enameled
frame, first appeared in Guler painting and became widespread throughout the Kan-
gra Valley by 1800.[4]

[1]*Coomaraswamy 1916*, 1:69–70. See also A. K. Coomaraswamy, "Rajput Painting,"
 Bulletin, Museum of Fine Arts, Boston 16 (1918): 54.
[2]*Coomaraswamy 1916*, 1:21–25; *Coomaraswamy 1926*, pp. 147–69. See also *Archer
 1952*, pp. 5–6.
[3]See the Kangra section in *Archer 1973* for the inscribed portraits. A short discussion
 of this problem can be found in *Welch and Beach*, no. 46.
[4]See *Binney: Rajput*, pp. 111, 113, 115, 119, 122.

Exhibitions:
WAM 1926
Chicago 1926
The Asia Society, New York, 29 November 1960–22 January 1961

Literature:
Coomaraswamy 1916, 1: 69, 2: pl. 71A (as *The Pet Deer*).
WAM Bulletin 17, no. 1 (April 1926): 19 (illus.).
WAM Annual Report 31 (1927): 32.
Objects.
S. E. Lee, *Rajput Painting* (New York: [Asia Society, 1960]), p. 84 (illus.).

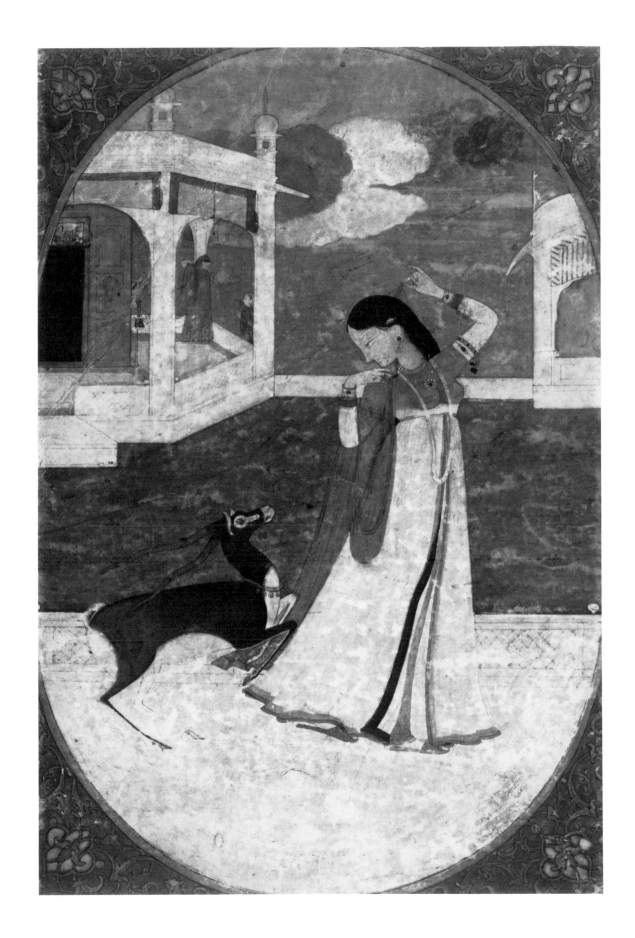

The Storm

Punjab Hills, Guler, ca. 1760–70
16.7 x 12.1 cm painting; 16.8 x 12.2
cm page
Gift of Alexander H. Bullock, 1956.3
Ex. coll.: A. K. Coomaraswamy

Hurrying for shelter from the oncoming storm, a lady pulls her veil over her head. The wind catches and fills it as she bends before the blast. Above a peacock sits on the edge of the roof, pleased at the prospect of rain and, by implication, of love.

Here, as in *Madhu-Mādhavī Rāginī* (p. 42), we meet the *abhisārikā nāyikā*, a woman stealing off through the wind and rain to meet her lover. At court the monsoon was a favored season for love-making, for the courtier could stay at home while the lady ventured forth through the perilous storm. For a woman at court, braving the elements to reach her lover was a romantic and welcome release from the tedium of daily life; hence, the *abhisārikā* was a popular image.

Despite the anticipation of pleasure in her face, the impassioned sweep of the lady's clothes mirrors the turmoil that must be in her heart. As the poet Vidyāpati wrote,

"How the rain falls
In deadly darkness!
O gentle girl, the rain
Pours on your path
And roaming spirits straddle the wet night.
She is afraid.... "[1]

The peacock on the roof heralds a night of love-making. Although the images of sacred love (for spiritual perfection) were often the same as those for profane love (for erotic pleasure and propagation), and although the two loves often overlapped in peoples' minds, they are not always associated with one another. Since this painting, unlike *Krishna Disguised as a Musician* (p. 60), has no clearly spiritual iconography to suggest sacred love, its message is profane: the romance and danger of an illicit affair.

Figures in motion were popular subjects of painters from the Kangra Valley, particularly from Guler. Here the figure is spontaneous, natural, and eminently graceful despite the circumstances of the setting.[2] The simple composition (but for the bare outlines of a building, the peacock, and a cloud, the lady would be alone) is also typical of Kangra Valley painting, which, in examples such as this, no longer uses the geometric structures so often found in Rajput works.

[1] D. Bhattacharya, trans., and W. G. Archer, ed., *Love Songs of Vidyāpati* (London: George Allen & Unwin Ltd., 1963), p. 57.
[2] Cf. *Heeramaneck*, no. 74; *Archer 1952*, p. 7, fig. 1.

Exhibitions:
WAM 1926
Chicago 1926
Art Objects Owned in and near Worcester, Worcester Art Museum, 18 November 1950–1 January 1951
Smith 1980

Literature:
Coomaraswamy 1916, 2: pl. 71B; see also 1:22, 54.
WAM Annual Report 60 (1956): 14 (as *The Storm, a Lady Taking Shelter from the Monsoon Wind and Rain*).
A Handbook to the Worcester Art Museum (Worcester: Worcester Art Museum, 1973), p. 205 (illus.).

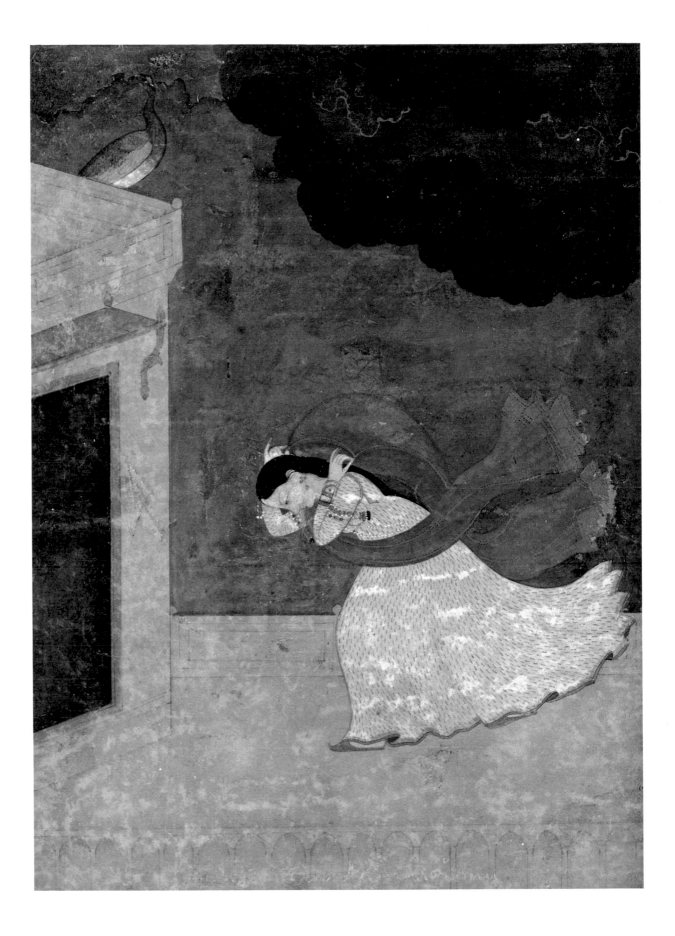

Designed by Logowitz + Moore Design Associates
Type set in Sabon by Monotype Composition Company
Printed by Acme Printing Company, Inc. on Warren's Lustro Offset Enamel Dull

Photography by Ron White